**PAINT ALONG WITH JERRY YARNELL** • *VOLUME SIX*

# *LEARNING*
# Composition

**ABOUT THE AUTHOR** Jerry Yarnell was born in Tulsa, Oklahoma, in 1953. A recipient of two scholarships from the Philbrook Art Center in Tulsa, Jerry has always had a great passion for nature and has made it a major thematic focus in his painting. He has been rewarded for his dedication with numerous awards, art shows and gallery exhibits across the country. His awards include the prestigious Easel Award from the Governor's Classic Western Art Show in Albuquerque, New Mexico, acceptance in the top 100 artists represented in the national Art for the Parks Competition, an exhibition of work in the Leigh Yawkey Woodson Birds in Art Show and participation in a premier showing of work by Oil Painters of America at the Prince Gallery in Chicago, Illinois.

Jerry has another unique talent that makes him stand out from the ordinary: He has an intense desire to share his painting ability with others. For years he has taught successful painting workshops and seminars for hundreds of people. Jerry's love for teaching also keeps him very busy offering workshops and private lessons in his new Yarnell Studio & School of Fine Art. Jerry is the author of several books on painting instruction, and his unique style can be viewed on his popular PBS television series, *Jerry Yarnell School of Fine Art,* airing worldwide.

**Paint Along with Jerry Yarnell, Volume 6: Learning Composition.** © 2003 by Jerry Yarnell. Manufactured in China. All rights reserved. No part of this book may be reproduced in any form or by any electronic or mechanical means including information storage and retrieval systems without permission in writing from the publisher, except by a reviewer, who may quote brief passages in a review. Published by North Light Books, an imprint of F&W Publications, Inc., 4700 E. Galbraith Road, Cincinnati, Ohio 45236. (800) 289-0963. First edition.

Other fine North Light Books are available from your local bookstore or art supply store or direct from the publisher.

07  06  05  04  03    5  4  3  2  1

Library of Congress Cataloging-in-Publication Data

Yarnell, Jerry.
    Paint along with Jerry Yarnell.
        p. cm.
    Includes index.
    Contents: v. 6. Learning composition
    ISBN 1-58180-378-8 (pbk. : alk. paper)
        1. Acrylic painting—Technique. 2. Landscape painting—Technique. I. Title

ND1535 .Y37 2003
751.4'26—dc21                                  00-033944
                                                      CIP

Editor: Maria Tuttle
Designer: Nicole Armstrong
Production Coordinator: Mark Griffin
Photographer: Scott Yarnell

## DEDICATION

It was not difficult to know to whom to dedicate this book. I give God all the praise and glory for my success. He blessed me with the gift of painting and the ability to share this gift with people around the world. He has blessed me with a new life after a very close brush with death. I am here today and able to share all of this with each of you because we have a kind, loving and gracious God. Thank you, God, for all you have done.

Also to my wonderful wife, Joan, who has sacrificed and patiently endured the hardships of an artist's life. I know she must love me or she would not still be with me. I love you, sweetheart, and thank you. Lastly, to my two sons, Justin and Joshua: You both are a true joy in my life.

## ACKNOWLEDGMENTS

So many people deserve recognition. First, I want to thank the thousands of students and viewers of my television show for their faithful support over the years. Their numerous requests for instructional materials are really what initiated the process of producing these books. I want to acknowledge my wonderful staff, Diane, Scott and my mother and father for their hard work and dedication. In addition, I want to recognize the North Light staff for their belief in my abilities.

## FOR MORE INFORMATION

about the Yarnell Studio & School of Fine Art and to order books, instructional videos and painting supplies contact:

Yarnell Studio & School of Fine Art
P.O. Box 808
Skiatook, OK 74070

Phone: (877) 492-7635

Fax: (918) 396-2846

gallery@yarnellart.com

www.yarnellart.com

## METRIC CONVERSION CHART

| TO CONVERT | TO | MULTIPLY BY |
| --- | --- | --- |
| Inches | Centimeters | 2.54 |
| Centimeters | Inches | 0.4 |
| Feet | Centimeters | 30.5 |
| Centimeters | Feet | 0.03 |
| Yards | Meters | 0.9 |
| Meters | Yards | 1.1 |
| Sq. Inches | Sq. Centimeters | 6.45 |
| Sq. Centimeters | Sq. Inches | 0.16 |
| Sq. Feet | Sq. Meters | 0.09 |
| Sq. Meters | Sq. Feet | 10.8 |
| Sq. Yards | Sq. Meters | 0.8 |
| Sq. Meters | Sq. Yards | 1.2 |
| Pounds | Kilograms | 0.45 |
| Kilograms | Pounds | 2.2 |
| Ounces | Grams | 28.3 |
| Grams | Ounces | 0.035 |

# Table of Contents

INTRODUCTION . . . . . . . . . PAGE 6

TERMS & TECHNIQUES . . . . . PAGE 8

GETTING STARTED . . . . . . . PAGE 11

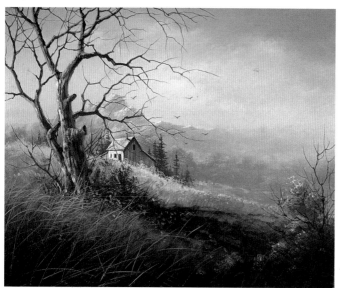

PROJECT ONE. . . . . . . . . . . . . . . . PAGE 42
## Country Getaway

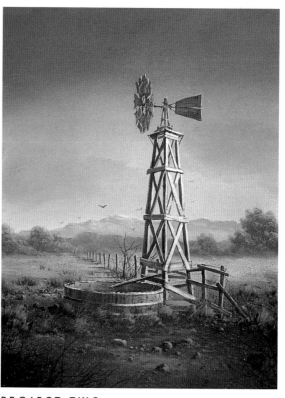

PROJECT TWO. . . . . . . . . . PAGE 54
## Prairie Relic

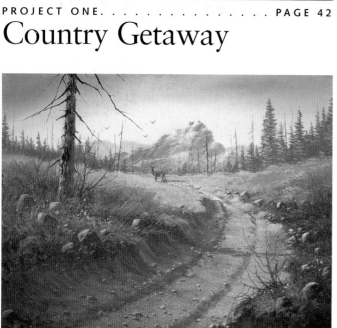

PROJECT THREE. . . . . . . . . . . . . PAGE 66
## Rocky Road

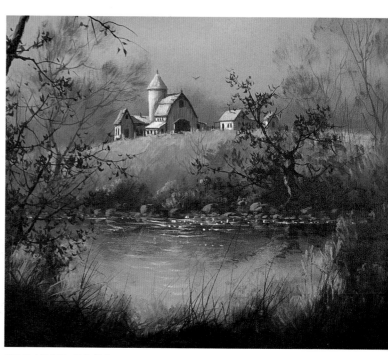

PROJECT FOUR. . . . . . . . . . . . . . PAGE 78
## A Peaceful Place

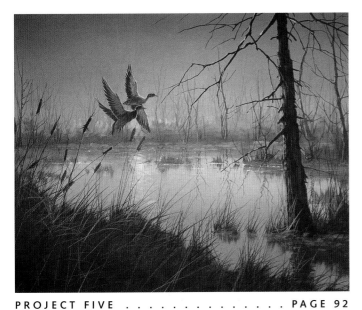

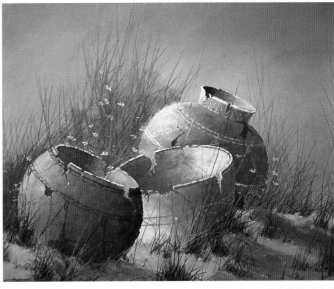

PROJECT FIVE . . . . . . . . . . . . . . . PAGE 92

# Homeward Bound

PROJECT SIX . . . . . . . . . . . . . . PAGE 104

# Broken Pots

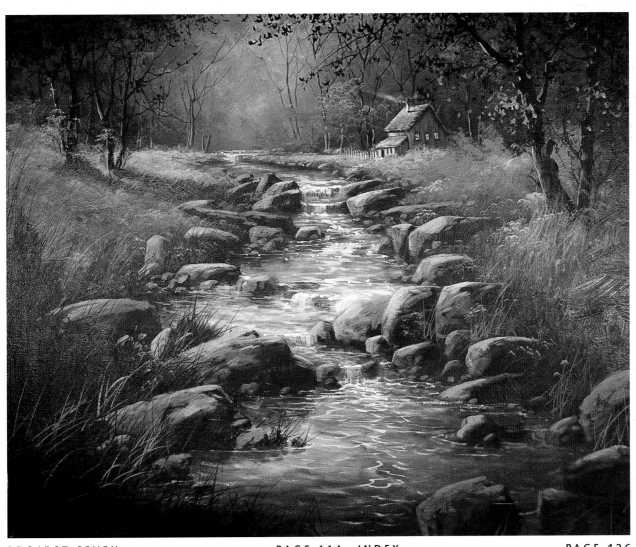

PROJECT SEVEN. . . . . . . . . . . . PAGE 114   INDEX. . . . . . . . . . . . PAGE 126

# Rocky Waters

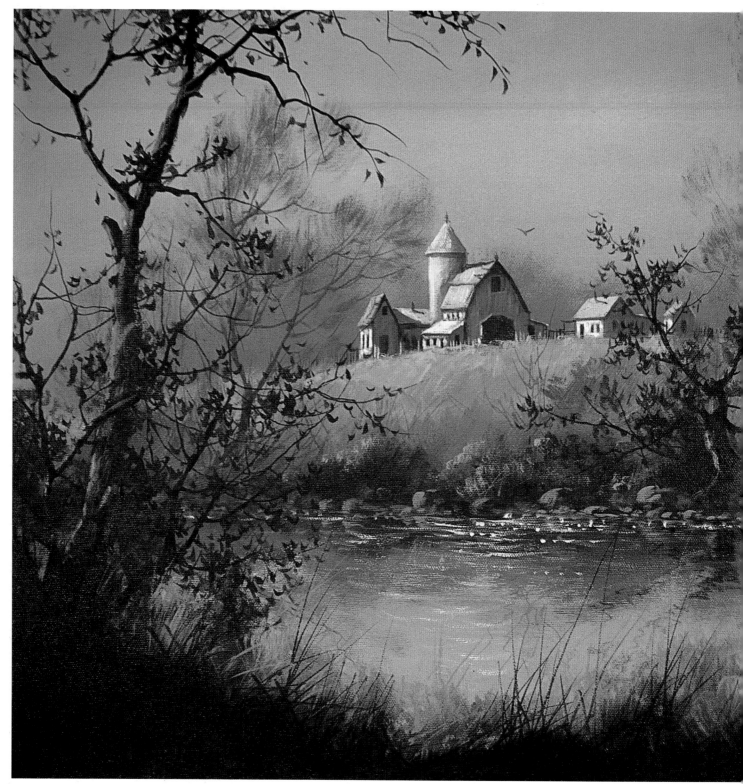

A Peaceful Place
16" × 20" (41cm × 51cm)

# Introduction

*Composition is one of the most misunderstood concepts in any form of artwork. It has been said that you can be the greatest painter in the world, but if you don't know how to compose properly, your painting will fall apart. I have had the thrill of winning numerous awards over the years, and I've asked many judges why a particular painting wins. The standard answer is that the painting has a strong composition and is well-designed. In this book, I will explore the different aspects of composition, including the three different types of composition, the principles of good design, the effective use of "eye stoppers," the proper use of negative space, how to locate the center of interest correctly and how to use thumbnail sketches. Composition is really about moving the viewer's eye. The challenge is to arrange all of the components of the composition so that it's a pleasure for the viewer to look at your painting. The demonstrations in this book will explain how good composition works, so that you too can make your paintings work.*

# Terms & Techniques

*Before beginning the step-by-step instructions on the following pages, you may want to refresh your memory by reviewing these terms and techniques.*

## COLOR COMPLEMENTS

Complementary colors always appear opposite each other on the color wheel. Use complements to create color balance in your paintings. It takes practice to understand how to use complements, but a good rule of thumb is to use the complement—or form of the complement—of the predominant color in your painting to highlight, accent or gray that color.

For example, if your painting has a lot of green, use its complement, red—or a form of red such as orange or red-orange—for highlights. If you have a lot of blue in your painting, use blue's complement, orange—or a form of orange such as yellow-orange or red-orange. The complement of yellow is purple or a form of purple. Keep a color wheel handy until you have memorized the color complements.

## DABBING

Use this technique to create leaves, ground cover, flowers, etc. Take a bristle brush and dab it on your table or palette to spread out the ends of the bristles like a fan (see above example). Then load the brush with the appropriate color and gently dab on that color to create the desired effect.

## DOUBLE LOAD OR TRIPLE LOAD

To load a brush this way, put two or more colors on different parts of your brush. Mix these colors on the canvas instead of your palette.

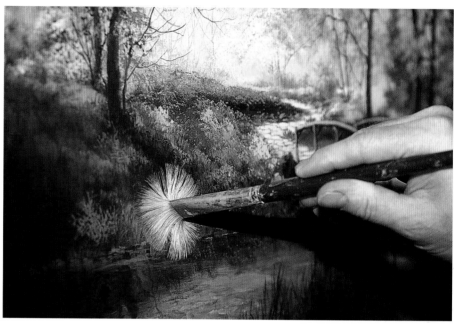

To prepare your bristle brush for dabbing, spread out the ends of the bristles like a fan.

Double or triple load your brush for wet-on-wet techniques.

## DRYBRUSH

Load your brush with very little paint and lightly skim the surface of the canvas with a very light touch to add, blend or soften a color.

## EYE FLOW

Create good eye flow and guide the viewer's eye through the painting with the arrangement of objects on your canvas or the use of negative space around or within an object. The eye must move smoothly, or flow, through your painting and around objects. The viewer's eyes shouldn't bounce or jump from place to place. Once you understand the basic components of composition—design, negative space, "eye stoppers," overlap, etc.—your paintings will naturally achieve good eye flow.

## FEATHERING

Use this technique to blend to create soft edges, to highlight and to glaze. Use a very light touch, barely skimming the surface of the canvas with your brush.

## GESSO

Gesso is a white paint used for sealing canvas before painting on it. Because of its creamy consistency, and because it blends so easily, I often use gesso instead of white paint. When I use the word gesso in my step-by-step instructions, I am refer-

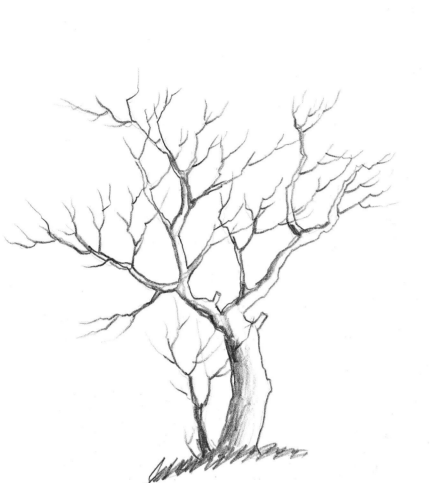

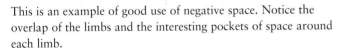

This is an example of good use of negative space. Notice the overlap of the limbs and the interesting pockets of space around each limb.

This is an example of poor use of negative space. Notice the limbs do not overlap but are evenly spaced instead. There are few pockets of interesting space.

ring to the color white. Use gesso or whatever white pigment you prefer.

### GLAZE (WASH)

A glaze or a wash is a very thin layer of paint applied over a dry area to create mist, fog, haze or sun rays or to soften an area that is too bright. Dilute a small amount of color with water and apply it to the appropriate area. You can apply the glaze in layers, but each layer must be dry before applying the next.

### HIGHLIGHTING OR ACCENTING

Highlighting is one of the final stages of your painting. Use pure color or brighter values to give your painting its final glow. Carefully apply highlights on the sunlit edges of the most prominent objects in your paintings.

### MIXING

If you will be using a mixture often, premix a good amount of that color to have handy. I usually mix colors with my brush, but sometimes a palette knife works better. Be your own judge.

I also sometimes mix colors on my canvas. For instance, when I am underpainting grass, I may put two or three colors on the canvas and scumble them together to create a mottled background of different colors. This method also works well for skies.

When working with acrylics, always mix your paint to a creamy consistency that will blend easily.

### NEGATIVE SPACE

Negative space surrounds an object to define its form and create good eye flow (see above example).

### SCRUBBING

Scrubbing is similar to scumbling (below), but the strokes should be more uniform and in horizontal or vertical patterns. Use a dry-brush or wet-on-wet technique with this procedure. I often use it to underpaint or block in an area.

## SCUMBLING

Use a series of unorganized, overlapping strokes in different directions to create effects like clumps of foliage, clouds, hair and grass. The direction of the stroke is not important for this technique.

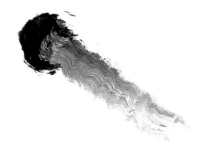

## UNDERPAINTING AND BLOCKING IN

The first step in all paintings is to block in or underpaint the dark values. You'll apply lighter values of each color to define each object later.

## VALUE

Value is the relative lightness or darkness of a color. To achieve depth or distance, use lighter values in the background and darker values closer to the foreground. Lighten a color by adding white. Make a value darker by adding black, brown or the color's complement.

## WET-ON-DRY

I use this technique most often in acrylic painting. After the background color is dry, apply the topcoat by drybrushing, scumbling or glazing.

## WET-ON-WET

Blend the colors together while the first application of paint is still wet. I use a large hake (pronounced haKAY) brush to blend large areas, such as skies and water, with the wet-on-wet technique.

You can lighten the value of a color by adding white.

# Getting Started

## Acrylic Paint

The most common criticism of acrylics is that they dry too fast. Acrylics do dry very quickly because of evaporation. To solve this problem I use a wet palette system (see pages 13-15). I also use very specific dry-brush blending techniques to make blending very easy. With a little practice you can overcome any of the drying problems acrylics pose.

Acrylics are ideally suited for exhibiting and shipping. You actually can frame and ship an acrylic painting thirty minutes after you finish it. You can apply varnish over an acrylic painting, but you don't have to because acrylic paint is self-sealing. Acrylics are also very versatile because you can apply thick or creamy paint to resemble oil paint or paint thinned with water for watercolor techniques. Acrylics are non-toxic, with very little odor, and few people have allergic reactions to them.

### USING A LIMITED PALETTE

I work from a limited palette. Whether for professional or instructional pieces, a limited palette of the proper colors is the most effective painting tool. It teaches you to mix a wide range of shades and values of color, which every artist must be able to do, Second, and eliminates the need to purchase dozens of different colors.

With a basic understanding of the color wheel, the complementary color system and values, you can mix thousands of colors for every type of painting from a limited palette.

For example, mix Phthalo Yellow-Green, Alizarin Crimson and a touch of Titanium White (gesso) to create a beautiful basic flesh tone. Add a few other colors to the mix to create earth tones for landscape paintings. Make black by mixing Ultramarine Blue with equal amounts of Dioxazine Purple and Burnt Sienna or Burnt Umber. The list goes on and on, and you'll see that the sky isn't even the limit.

Most paint companies make three grades of paints: economy, student and professional. Professional grades are more expensive but much more effective. Just buy what you can afford and have fun. Check your local art supply store first. If you can't find a particular item, I carry a complete line of professional- and student-grade paints and brushes (see page 3).

---

**MATERIALS LIST**

**Palette**

white gesso
*Grumbacher, Liquitex or Winsor & Newton paints (color names may vary):*

  Alizarin Crimson
  Burnt Sienna
  Burnt Umber
  Cadmium Orange
  Cadmium Red Light
  Cadmium Yellow Light
  Dioxazine Purple
  Hooker's Green Hue
  Phthalo (Thalo) Yellow-Green
  Titanium White
  Ultramarine Blue

**Brushes**

no. 4 flat sable brush
no. 4 round sable brush
no. 4 script liner brush
no. 6 flat bristle brush
no. 10 flat bristle brush
2-inch (51mm) hake brush

**Miscellaneous Items**

16" × 20" (41cm × 51cm) stretched canvas
charcoal pencil
easel
no. 2 soft vine charcoal
palette knife
paper towels
Sta-Wet palette
spray bottle
water can

# Brushes

I use a limited number of brushes for the same reasons as the limited palette—versatility and economics.

### 2-INCH (51MM) HAKE BRUSH

Use this large brush for blending, glazing and painting large areas, such as skies and bodies of water with a wet-on-wet technique.

### NO. 10 FLAT BRISTLE BRUSH

Underpaint large areas—mountains, rocks, ground or grass—and dab on tree leaves and other foliage with this brush. It also works great for scumbling and scrubbing techniques. The stiff bristles are very durable, so you can treat them fairly roughly.

### NO. 6 FLAT BRISTLE BRUSH

Use this brush, a cousin of the no. 10 flat bristle brush, for many of the same techniques and procedures. The no. 6 flat bristle brush is more versatile than the no. 10 because you can use it for smaller areas, intermediate details and highlights. You'll use the no. 6 and no. 10 flat bristle brushes most often.

### NO. 4 FLAT SABLE BRUSH

Use sable brushes for more refined blending, painting people and highlights, and adding details to birds and other animals. Treat these brushes with extra care because they are more fragile and more expensive than bristle brushes.

### NO. 4 ROUND SABLE BRUSH

Use this brush, like the no. 4 flat sable, for details and highlights. The sharp point of the round sable, though, allows more control over areas where a flat brush will not work or is too wide. This is a great brush for finishing a painting.

### NO. 4 SCRIPT LINER BRUSH

This brush is my favorite. Use it for very fine details and narrow line work, such as tree limbs, wire, weeds and especially your signature, that you can't accomplish with any other brush. Roll the brush in an ink-like mixture of pigment until the bristles form a fine point.

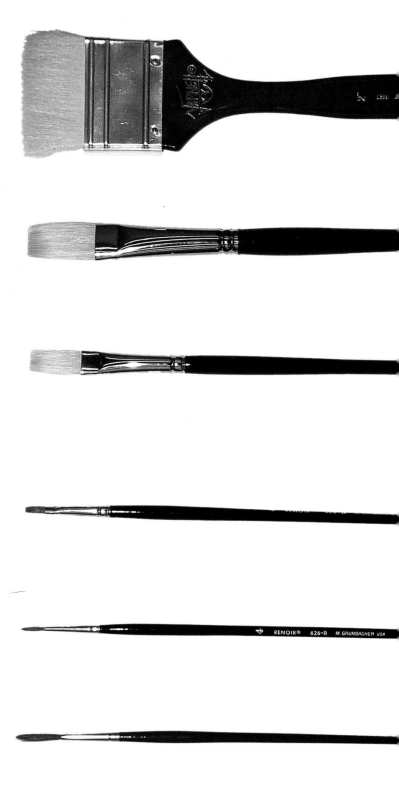

## BRUSH-CLEANING TIPS

As soon as you finish your painting, use quality brush soap and warm water to clean your brushes thoroughly before the paint dries. Lay your brushes flat to dry. Paint is very difficult to get out if you allow it to dry on your brushes or clothes. If this does happen, use denatured alcohol to soften the dried paint. Soak the brush in the alcohol for about thirty minutes and then wash it with soap and water.

Tip

Chisel Corner

Chisel Edge

Flat Side

Metal Ferrule

Handle

Brush diagram

## Palettes

Acrylics dry because of evaporation, so keeping the paints wet is critical. I use two Sta-Wet palettes made by Masterson. The first palette is a 12" × 16" (31cm × 41cm) plastic palette-saver box with an airtight lid (see page 14). Saturate the sponge that comes with the palette with water and lay it in the bottom of the box. Then soak the special palette paper and lay it over the sponge. Place your paints around the edges and you are ready to go. Use a spray bottle to mist your paints occasionally so they will stay wet all day long. When you are finished painting, attach the lid and your paint will stay wet for days.

My favorite palette is the same palette with a few alterations (see page 15). Instead of the sponge and special paper, I place a piece of double-strength glass in the bottom of the palette. I fold paper towels into quarters to make long strips, saturate them with water and lay them on the outer edges of the glass. I then place my paints on the paper towels. They stay wet for days. I occasionally mist them to keep the towels wet.

If you leave your paints in a sealed palette for several days without opening it, certain colors, such as Hooker's Green Hue and Burnt Umber, will mildew. Just replace the color or add a few drops of chlorine bleach to the water in the palette to help prevent mildew.

To clean the glass palette, allow it to sit in water for about thirty seconds or spray the glass with your spray bottle. Scrape off the old paint with a single-edge razor blade.

# Setting Up Your Palette

Here are two different ways to set up your palette.

**PALETTE 1**

The Sta-Wet 12" × 16" (31cm × 41cm) plastic palette-saver box comes with a large sponge that you saturate with water.

Lay the sponge inside the palette box, soak the special palette paper and lay it over the sponge. Place your paints around the edges. Don't forget to mist them to keep them wet.

When closing the palette-saver box, make sure the airtight lid is on securely. When the palette is properly sealed, your paints will stay wet for days.

**PALETTE 2**

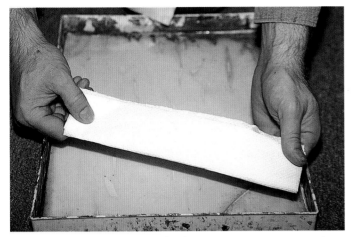

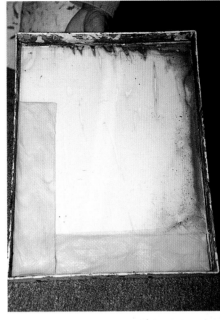

Lay the saturated paper towels around the outer edges of the glass.

Instead of using the sponge and palette paper, you can use a piece of double-strength glass in the bottom of the palette. Fold paper towels in long strips and saturate them with water.

Place your paints on the paper towel strips.

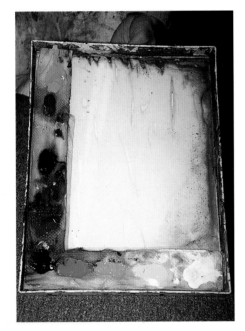

Use the center of the palette for mixing paints. Occasionally spray a mist over the paper towels to keep them wet.

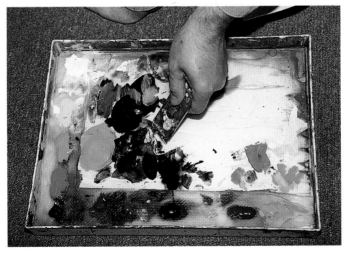

To clean the palette, allow it to sit for thirty seconds in water or spray the glass with a spray bottle. Scrape off the old paint with a single-edge razor blade.

# Miscellaneous Supplies

### CANVAS

Canvas boards work for practicing strokes, and canvas paper pads work for studies or testing paints and brush techniques. The best surface for painting, though, is a primed, prestretched cotton canvas with a medium texture, which you can find at most art stores. As your skills advance, you may want to learn to stretch your own canvas, but 16" × 20" (41cm × 51cm) prestretched cotton canvases are all you'll need for the paintings in this book.

### EASEL

I prefer a sturdy, standing easel. My favorite is the Stanrite ST500 aluminum easel. It is lightweight, sturdy and easy to fold up to take on location or to workshops.

### LIGHTING

Of course, the best light is natural north light, but most of us don't have this light in our work areas. The next best lighting option is to hang 4' (1.2m) or 8' (2.4m) fluorescent lights directly over your easel. Place one cool bulb and one warm bulb in the fixture to best simulate natural light.

Studio lights

16" × 20" (41cm × 51cm) prestretched canvas

Aluminum Stanrite studio easel

### SPRAY BOTTLE

I use a spray bottle with a fine mist to lightly wet my paints and brushes throughout the painting process. I recommend a spray bottle from a beauty supply store. It's important to keep one handy.

### PALETTE KNIFE

I use my palette knife more for mixing than for painting. A trowel-shaped knife is more comfortable and easier to use than a flat knife.

### SOFT VINE CHARCOAL

I use no. 2 soft vine charcoal for most of my sketching. It's very easy to work with, shows up well and is easy to remove with a damp paper towel.

Spray bottle

Soft vine charcoal

Palette knives

# Composition and Center of Interest

A simple but accurate definition of composition is the arrangement of objects on your canvas that please the eye. That sounds simple enough, but how do you make it work?

As an artist, your main goal is to get the viewer's eye to travel through your artwork and reach the main focal point or center of interest with little or no interference from the other objects on the canvas. The three types of composition that we will discuss in the following pages are: L-shape composition, triangle-shape composition and center-type composition. Each of these types of composition has certain elements in common that make your painting work as a whole.

## Elements of Composition

In the following pages we will look at some common elements that help bring a painting together and then discuss them with some examples. The following are the six common elements found in all compositions:
1. Center of interest or focal point
2. Eye stoppers
3. Negative space
4. Fillers
5. Light source and shadows
6. Overlapping

Keep in mind that each of these elements is critical to the success of your composition. They must all be present and planned in advance before you begin to paint. Remember, you may be the best painter in the world, but without a strong composition, your painting will fall apart.

## Center of Interest

The first and most important aspect of composition is the focal point or center of interest, the one spot in your painting where your eye ultimately ends up.

Once you decide what your center of interest is and where you want to place it, you can begin adding all of the other elements of composition that help your eye flow through the painting. The goal in any painting is to lead the eye to your center of interest.

It takes a lot of thought and careful planning to make all the elements of composition successful. The first example shows a completed painting with the center of interest and other elements of composition working together.

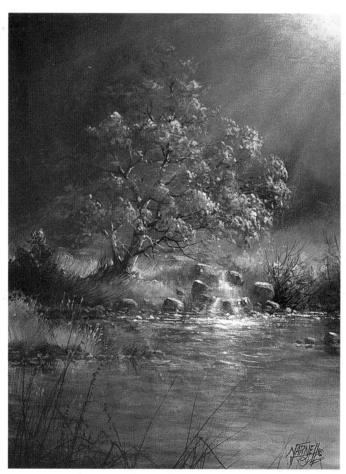

**Focal Points Make a Strong Composition**
It's fairly obvious in this painting that the main center of interest is the redbud tree. Notice, however, that the small waterfall is also part of the focal area but is not necessarily the main interest. The waterfall does not compete with the redbud tree, but plays an important role by helping your eye stay focused on it.

# Eye Stoppers

Eye stoppers are various objects placed in your painting that keep the viewer's eye from wandering off the canvas. Eye stoppers should never compete with the main eye flow or center of interest. Eye stoppers are a necessary element in all types of composition.

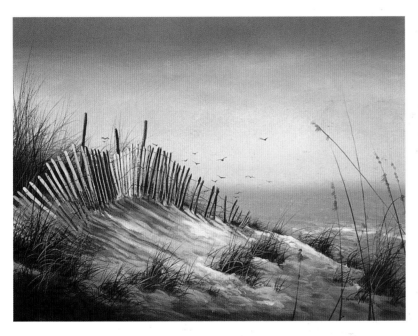

### Elements Stop the Eye
Notice how the tall weeds in the right-hand corner stop your eye from moving off the canvas. The tall weeds are so tall that they break the plane of the horizon and help to lead your eye into the painting. Just as your eye flows around a sculpture, eye stoppers are the key factor in helping your eye flow throughout the canvas.

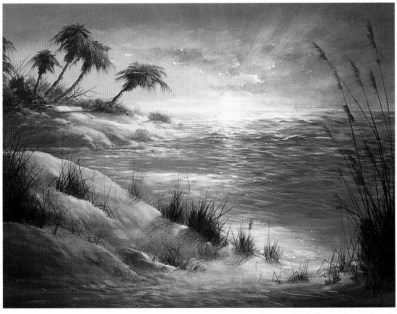

### Effective Eye Stoppers
The weeds on the right also lead your eye back into the painting. The smaller clumps of weeds on the left serve a similar purpose. Even the dark shadow in the corner is an eye stopper. The main eye stoppers, the palm trees, stop your eye in a dramatic fashion so your attention goes right back to the center of interest—the glowing sun.

# Effective Negative Space

Negative space is the empty space that surrounds an object or is within an object that gives it form. Let's look at the following examples.

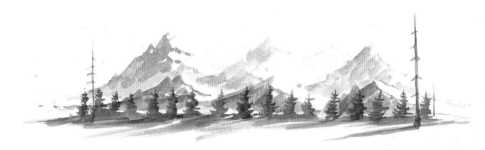

**Bad Negative Space**
This is an example of ineffective negative space. The height of the mountain ranges and the negative space between each range are the same. All the pine trees are the same height and the same basic shape of each tree and the negative space between each tree is about the same. Overall, this example is not interesting to look at because negative space is not utilized well.

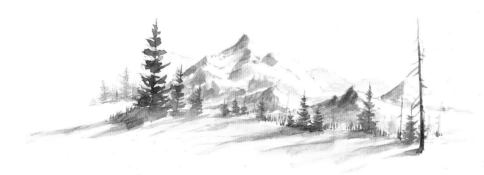

**Good Negative Space**
The same subjects arranged with good negative space make this example more interesting. The mountains are different shapes, and are surrounded by interesting pockets of negative space. Additionally, the pine trees are different heights and shapes and overlap each other.

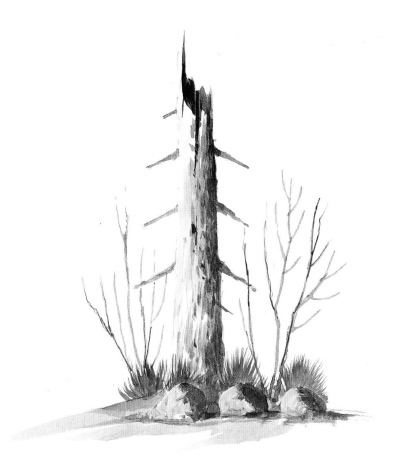

**Bad Negative Space**

This example could be very interesting, but fails because of poor use of negative space. The tree is vertical and the limbs are evenly spaced. The clumps of grass are all the same height and shape and the bushes and rocks don't overlap. The arrangement is located on flat ground, which makes the composition static and uninteresting.

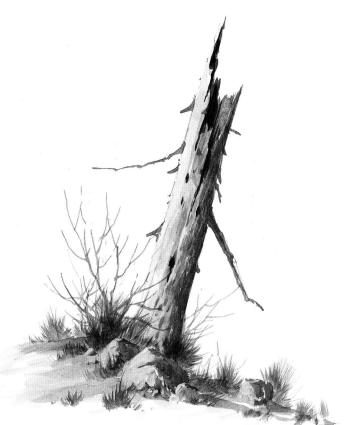

**Good Negative Space**

This is an example of good negative space. Using the same objects, notice how everything works together. The tree is angled. The limbs are irregular shapes and are unevenly spaced and the clumps of grass overlap and are different heights. Placing the elements on a hillside rather than on flat ground makes the whole arrangement much more interesting.

# Fillers and Light Source

Fillers are the odds and ends that you use to fill up the spaces around the center of interest. However, fillers should never compete with the main subject of your painting. They may seem insignificant, but they play a crucial role in holding your composition together.

Light source and shadows are two of the most important aspects of your composition. They should be one of the first things you consider when developing your design.

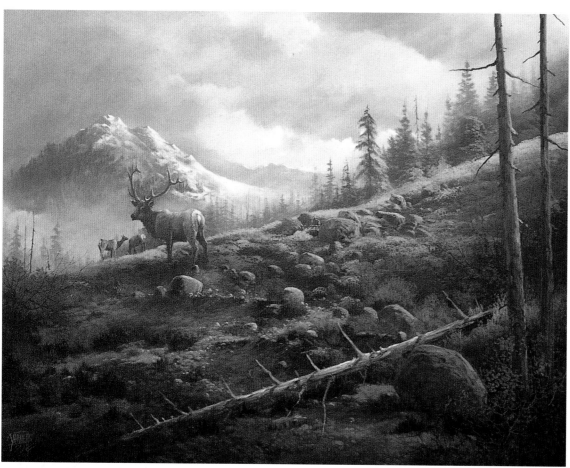

**Make Use of Fillers**
Because this is a complicated painting, you need fillers to help you focus on the center of interest. The main fillers are the background mountain, the pine trees, the boulders and the rocks. These elements complete the painting by giving it the atmosphere of a high country landscape. Miscellaneous fillers like the clouds, grass, flowers and pebbles add the finishing touches to make this composition work. Use fillers to enhance the center of interest, but don't let them interfere with your main focal point.

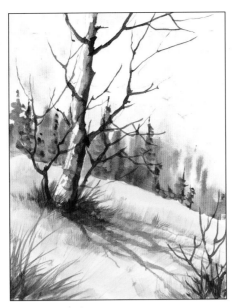

**Construct Strong Eye Flow**
Light source is an important factor when constructing eye flow. Notice that the shadow of the large tree moves your eye off the canvas. To solve this problem, change the direction of the light source. The cast shadows will move your eye back into the main part of the painting.

**Plan Your Light Source**
Changing the light source in a painting can dramatically improve the eye flow in your composition. By placing the shadows in the right spot, we can make much better use of the eye stoppers and other compositional elements. Keep in mind that all shadows should fall within the main body of the composition and should never lead your eye off the canvas. Before you choose the direction of your light source, remember that light can enter your painting from the left or right, above or below, and as backlight or front light. The light source will create the cast shadows in your painting that affect your eye flow. Be sure to point your cast shadows towards your main focal point.

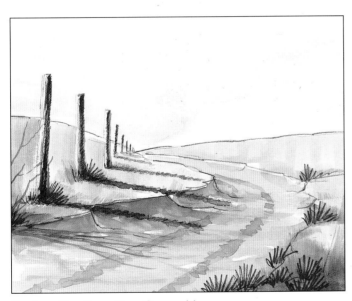

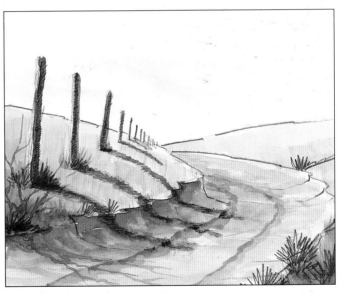

**Shadows Can Cause Poor Composition**
Many artists make this common mistake. The shadows are straight and don't follow the contour of the land. They appear to be floating. This creates a real eye flow problem, making for a poor composition.

**Shadows Can Improve Composition**
In the same basic composition, notice that the shadow of each fence post now follows the contour of the ground. The shadows follow the slope of the hill, then dip down the side of the gully. Shadows are deceiving. It's important to have a good understanding of how they will play into your painting's composition.

# Overlapping

Overlapping helps the viewer focus on your center of interest and creates unity in your painting. Even a great painting will have very little appeal without overlapping.

Overlapping is simply the touching of two objects or overlapping of one object over another to create good negative space and effective eye flow.

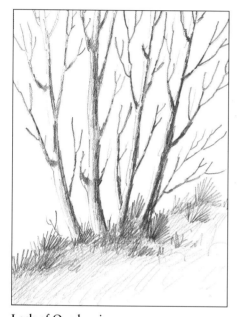

**Lack of Overlapping**
You'll notice that none of the trunks touch or overlap each other, creating numerous pockets of dull negative space.

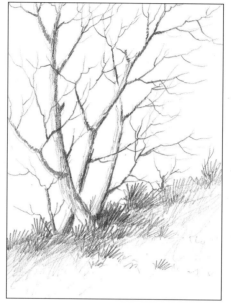

**Better Overlapping**
Overlapping the trunks and limbs dramatically changes the pockets of negative space. You can create a pleasing composition when objects overlap each other. The proper use of overlapping unifies all the elements in the painting.

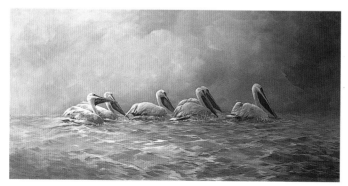

**Proper Use of Overlapping**
When you have several objects that are similar in shape or are grouped, like this gathering of pelicans, overlapping is crucial. Separating each pelican until they are evenly spaced makes your eye bounce rather than flow from pelican to pelican. Here, your eye moves gracefully through the unified group.

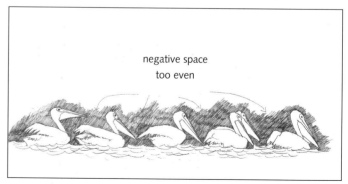

negative space too even

**Improper Overlapping**
I made a rough sketch of the same group of pelicans but spaced them evenly. Notice that your eye bounces from pelican to pelican instead of moving gracefully in and around them.

# Center-Type Composition

Now that you are familiar with the elements of composition, we'll discuss the three different types of composition.

The first type of composition we'll discuss is called center-type composition. This type is widely used in wildlife paintings, portraits, figure and still life paintings. As the name suggests, use this type of composition when there is one main center of interest. The drawback of using center-type composition is that it is difficult to design.

**Organize the Center of Interest**
The center of interest is strong in this example because it fills the canvas without the help of fillers. Miscellaneous fillers like the small pebbles, grass and shadows don't distract from the center of the composition. Because designing interesting negative space around the main center of interest is difficult, I used interesting negative space around other objects and in the shadows.

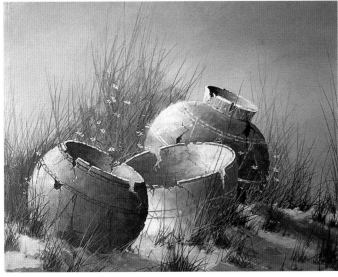

**Use Overlap to Activate Negative Space**
Here, as in the example above, the main challenge is composing the negative space around the pots so that your eye flows through the composition. The overlap rule is critical in activating the space in and around the pots.

# Triangle-Shape Composition

Use triangle-shape compositions primarily with several competitive or repetitive subjects arranged to create effective eye flow. Unlike other compositional types, triangle compositions have more than one subject.

There are three different types of triangle-shape compositions. The first has a center of interest and several triangle-shaped objects surrounding it that together form the points of a triangle. The second uses one center of interest and several objects surrounding it to create one large triangle.

The third triangle composition involves a single center of interest with several objects that surround it that are not necessarily triangular in shape. The center of interest is situated within the window of the triangle. In this composition, eye stoppers are extremely important because they keep our eye from wandering off the canvas.

This last triangle composition works well when there are several similar objects grouped together to make the center of interest. For example, a flock of birds, a herd of animals, a group of trees, buildings or any other repetitive objects work to create a main subject.

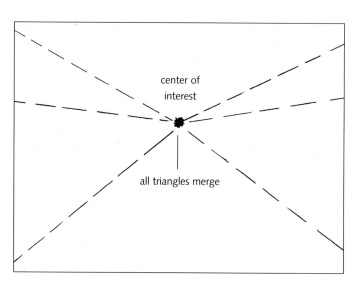

**First Triangle-Shape Composition**
In this very simple illustration, notice how the center of interest is surrounded by several triangle-shaped forms that merge and point towards the center of interest.

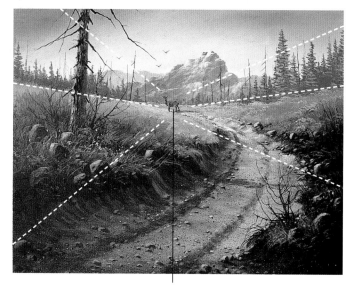

center of interest

**Surround the Center of Interest with Triangles**
In this painting, all of the objects that surround the center of interest form the basic shape of a triangle. The points of each triangle merge together and lead your eye towards the center of interest.

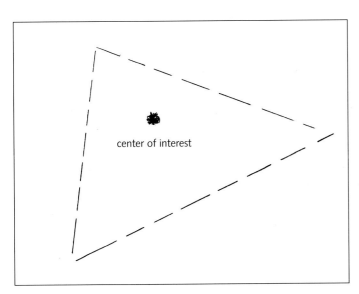

**Second Triangle-Shape Composition**
The center of interest is located within the triangle. Imagine that in the area surrounding the triangle are trees, clouds, rocks, hills and mountains.

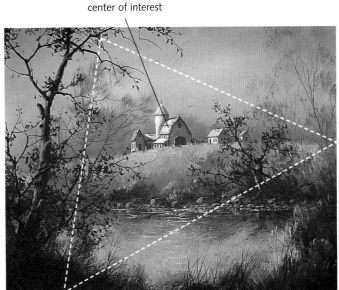

**Form a Window with Objects**
All of the objects that surround the center of interest form a window in the center of the triangle. These objects act as eye stoppers and fillers, but do not compete with the center of interest.

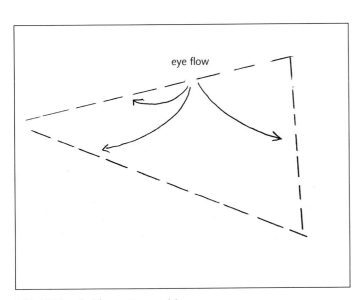

**Third Triangle-Shape Composition**
The viewer's eye flows along the shape of a triangle. Once you have established the direction of the eye flow, then you can begin adding other elements to the composition.

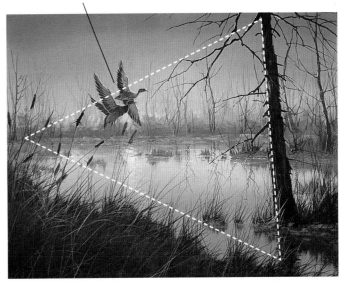

**Eye Flow Follows Triangle**
The ducks, tree stump and shoreline form the sides of the triangle. The other elements, or eye stoppers, help lead your eye around the composition and do not compete with the focal point.

# L-Shape Composition

The viewer's eye follows the shape of an L in this type of composition. Generally, you can use the L-shape composition for a painting that has very few objects.

In the example below, I mainly wanted to focus on the large tree and not much else in the painting. I made the tree the largest feature in the painting and set it left of center.

In an L-shape composition locate the fillers well within the eye flow of the L. Placing the tree left of center creates pockets of good negative space.

Keep in mind that no matter how simple your painting is, you still need to be sure that all of the elements of composition apply.

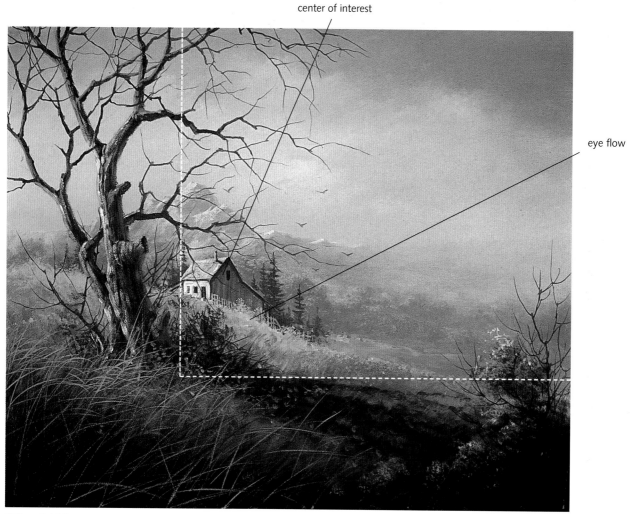

center of interest

eye flow

**Fillers Add Interest**
The main fillers in this example are the mountain, the house and the clouds. Notice that the fillers don't compete with the main center of interest—the tree. The main purpose of fillers is to fill up space and add interest to the painting. In this case, I have used the shadows as an important element to the flow of the painting.

eye flow

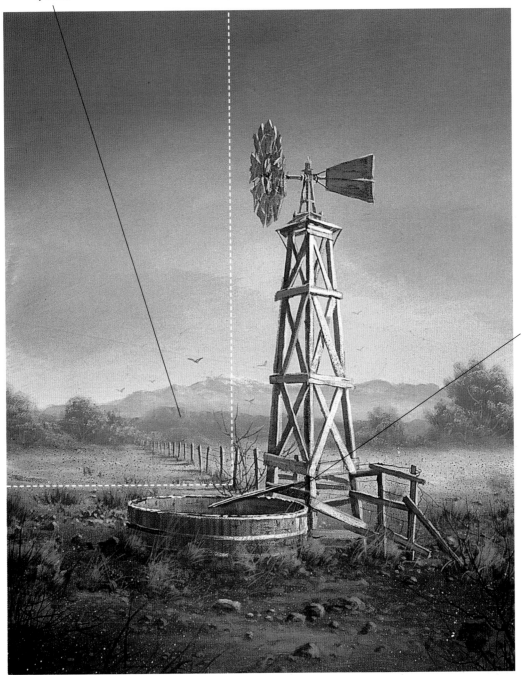

**Fillers Stay Within the L-Shape**
The negative space around the windmill is interesting because the main elements in the painting, the windmill and the watertank, are located slightly to the right of the center of interest. The fillers— the hills, trees, rocks and fence—are within the flow of the L so as not to compete with the main subject.

center of interest

# Designing a Sketch

Designing a sketch is the process of creating a balanced composition using all of the proper elements so the finished painting is pleasing to the eye. The best way to work out a good design is to do a series of thumbnail sketches. Thumbnail sketches are a great tool for working out compositional problems on a smaller scale before you begin your final painting.

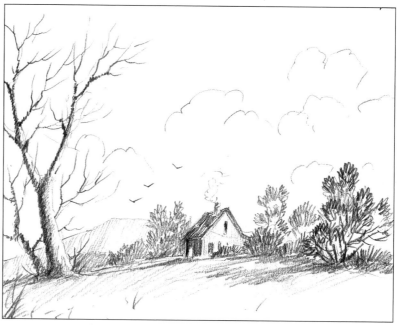

**Bad Design**

I'm not satisfied with this sketch. I placed the large tree too far to the left of the center of interest. The mountains need to be more dominant and the space between the tree and the cabin is uninteresting. I also need to figure out how to lead your eye into the painting. It's back to the drawing board. The main problem in this sketch is poor negative space. Changing the shape of the mountain can be a possible solution.

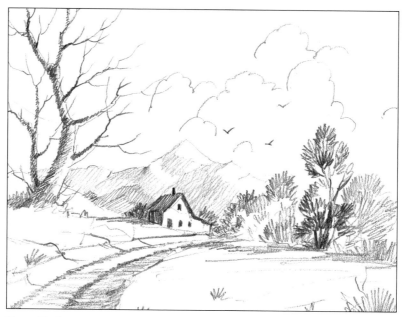

**Better Design**

I am more pleased with this design, but there are still many problems with the composition. I need to change the direction of the road and adjust the pocket of negative space to the right. The large tree is still too far to the left and may work better if it were closer to the foreground.

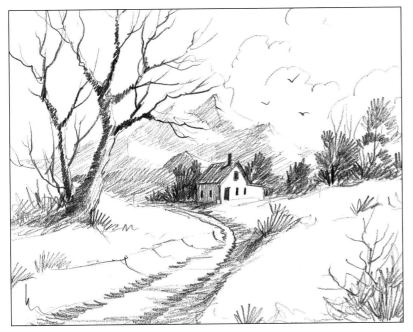

**Better Design**
Now we are making progress! The overall design is much improved. To add depth, I placed the large tree in the extreme foreground. I improved eye flow by curving the road in between the tree and the cabin. Even though I'm much more satisfied I still need to make a few adjustments. In the next thumbnail sketch, I'll work out a few more details before I paint the final study.

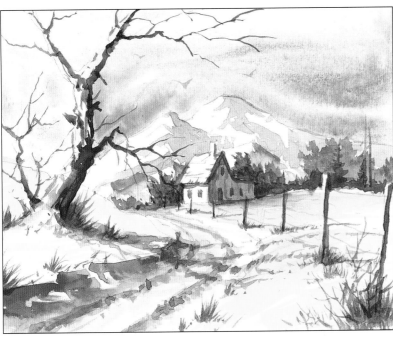

**Best Design**
The main purpose of this watercolor sketch is to be absolutely sure that I'm happy with everything before I transfer the work onto a larger canvas. Adding a little color helps me see things that I may have missed. Make pencil and watercolor thumbnail sketches part of your compositional design process, and your success rate will increase dramatically. I can work out final compositional problems like negative space, proportions, light source and basic color scheme before I transfer the idea to a canvas.

# More on Designing a Sketch

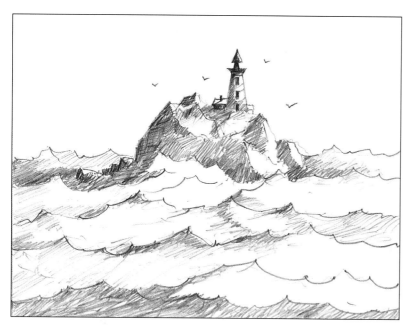

**Bad Design**
The rock formation and the lighthouse are placed in the middle of the canvas. Uninteresting pockets of negative space are on each side of the rock formation. Because of the placement, your eye does not flow through the painting. There are no eye stoppers and the waves are placed at even intervals.

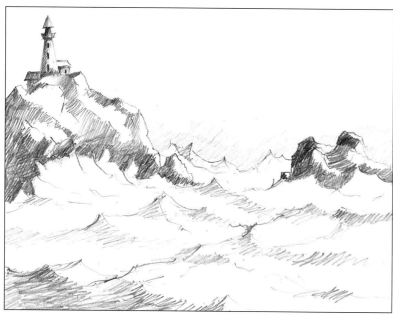

**Better Design**
In this example, I moved the main rock formation to the left side of the canvas and gave it a more interesting shape. I added a smaller group of rocks to balance the painting and act as eye stoppers. The waves are irregular intervals to add interest and eye flow.

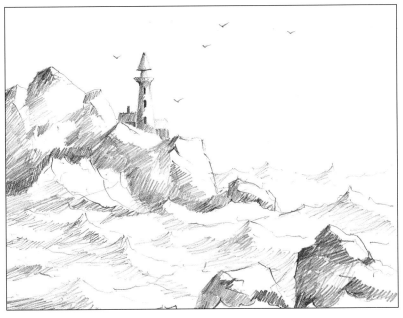

**Good Design**

I shifted the lighthouse further to the right, putting it in a more prominent position as a the center of interest. Now interesting pockets of negative space surround the lighthouse and rock formation. I moved the smaller rock formation closer to the foreground and into the right corner. A few small changes give the composition better eye flow and the rocks become dramatic eye stoppers.

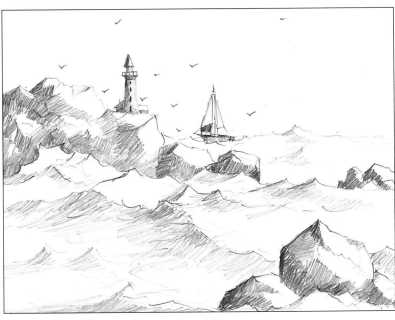

**Best Design**

For the final adjustments, I moved the rock formation further into the background to create depth. The waves are important to the overall composition. The sailboat is added fairly close to the rock formation. All of the subjects are within the eye flow.

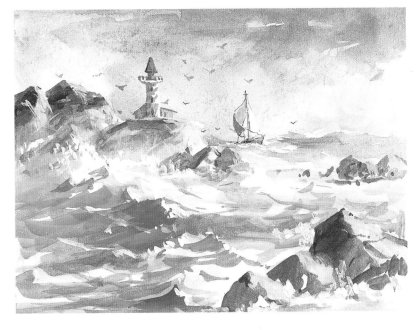

**Final Sketch**

The beauty of a color study is that you can add numerous value and color schemes that allow you to see how the final painting will take shape. By adding color, you can see more clearly the relationships between objects and the overall success of your final design. A color study will allow you to work out any compositional problems in advance.

# Making a Composite

A composite is a collection of photos, sketches or ideas that you use to create one piece of art. Using certain elements from each image and then applying the rules of composition, you can create a successful composition.

By using this process, the artist has endless opportunities to create the perfect composition. Grab your camera and sketch pad and begin making some composites of your own.

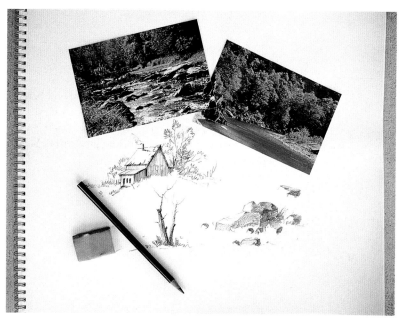

**Gather Reference Materials**
Once you've settled on a subject, gather your reference material. Here, I've gathered several different photos, along with a sketch. Next, I'll select subjects from each photo and begin arranging them in a thumbnail sketch.

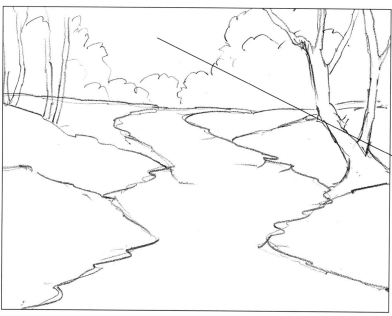

light source

**Make a Rough Sketch**
Sketch in the basic components of the landscape such as the location of the river, the surrounding landscape and the placement of the trees.

## Locate Your Center of Interest

Find an object that you want to use for your center of interest, and sketch it into your composition. Adjust the placement of your subject and make sure it's suitable for the type of composition you've chosen. In this case, I used a triangle-shape composition.

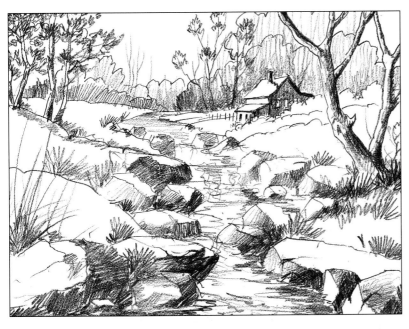

## Add Fillers

Once your center of interest is in place in your landscape, begin adding the fillers and the other elements that make up a successful composition. Remember, you may have to do several thumbnail sketches before you settle on a satisfying composition.

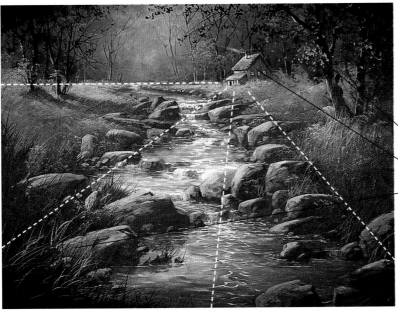

## Final Composite

This final composite is the result of careful planning. Of course, you can make adjustments in composition, design, color, values and proportions.

eye stoppers

center of interest

fillers

# Composition Tests: Painting One

Now that we've had a chance to look at the different types of composition and their basic elements, it might be fun to see if you can identify the composition types and elements used in the following paint-ings. In the space below each study, choose the type of composition already listed and the different elements of composition found in each one.

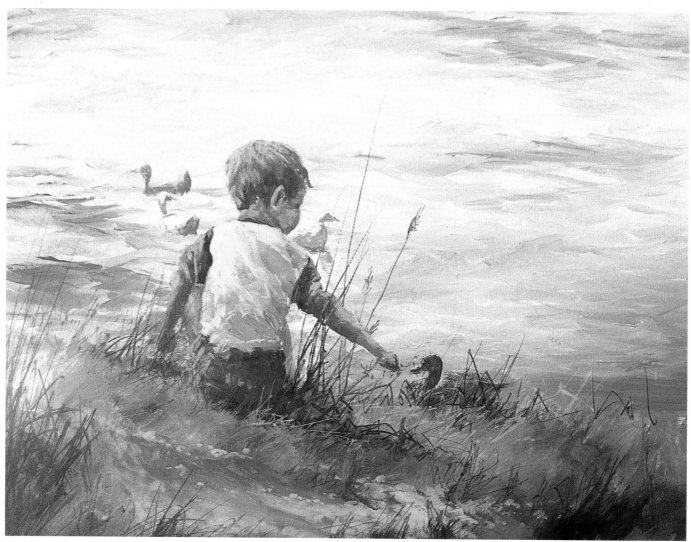

**Types of Composition**
Center-Type
Triangle-Shape
L-Shape

**Composition Elements**
Center of Interest
Eye Stoppers
Negative Space
Fillers
Light Source
Overlapping

# Painting Two

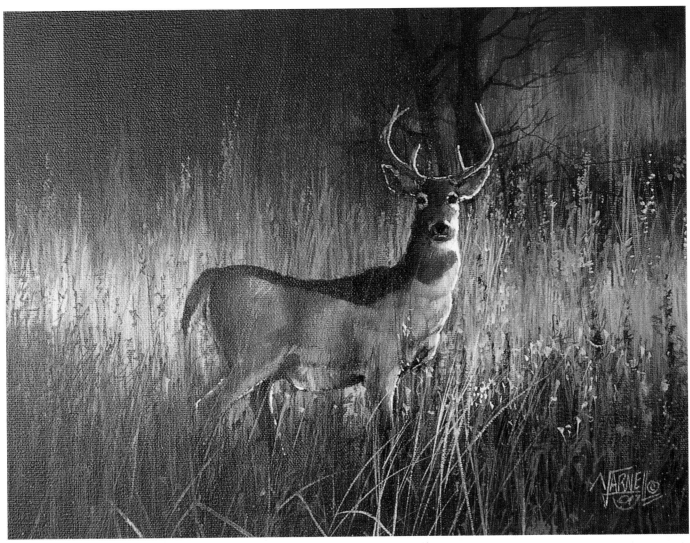

**Types of Composition**
Center-Type
Triangle-Shape
L-Shape

**Composition Elements**
Center of Interest
Eye Stoppers
Negative Space
Fillers
Light Source
Overlapping

# Painting Three

**Types of Composition**
Center-Type
Triangle-Shape
L-Shape

**Composition Elements**
Center of Interest
Eye Stoppers
Negative Space
Fillers
Light Source
Overlapping

# Painting Four

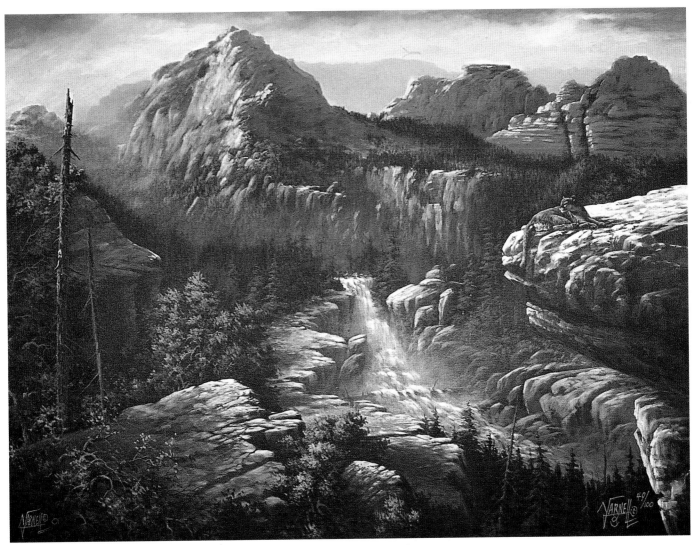

**Types of Composition**
Center-Type
Triangle-Shape
L-Shape

**Composition Elements**
Center of Interest
Eye Stoppers
Negative Space
Fillers
Light Source
Overlapping

# Painting Five

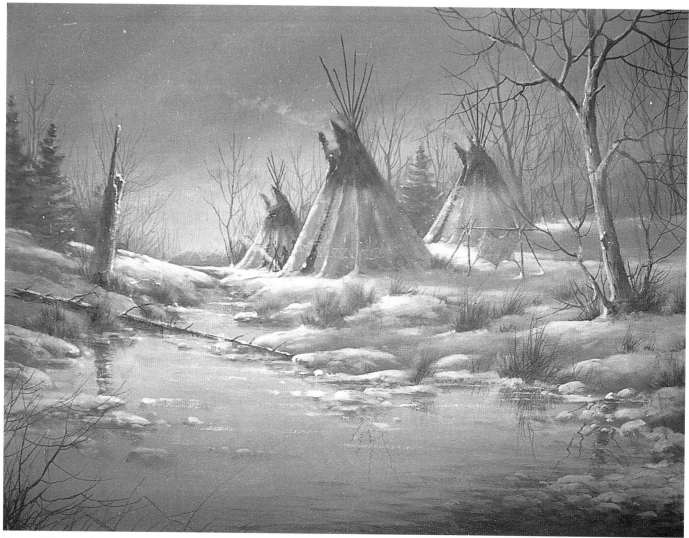

**Types of Composition**
Center-Type
Triangle-Shape
L-Shape

**Composition Elements**
Center of Interest
Eye Stoppers
Negative Space
Fillers
Light Source
Overlapping

# Composition Test Answers

center of interest

eye stopper   eye flow   fillers

**1**

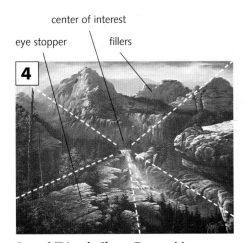

fillers

**2**

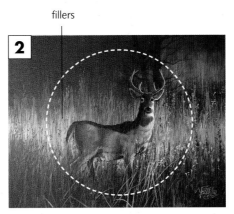

main center of interest

fillers   eye stopper

**3**

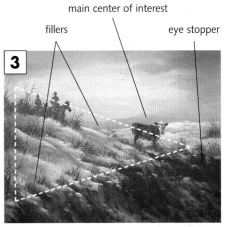

### L-Shape Composition
The shape of the figure and the cast shadow creates an L-shape eye flow. The eye stoppers and fillers such as the weeds, ducks and sand, don't compete with the center of interest and are well within the L-shape.

### Center-Type Composition
The deer is the center of interest in this composition. The grasses that surround the deer direct your eye toward the main subject. Even the tree highlights the head of the deer. The challenge in this example was simply working out the negative space in the background.

### First Triangle-Shape Composition
The main subject is the center of interest and forms the triangle itself. Eye stoppers such as the bushes and shadows, keep your attention focused on the main subject.

center of interest

eye stopper   fillers

**4**

eye stopper   center of interest   fillers

**5**

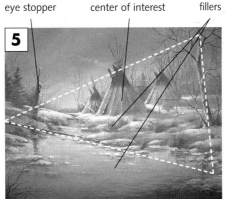

### Second Triangle-Shape Composition
Here we have another triangle-shape composition. The main focal point in this painting is the waterfall. The rock formations that surround the waterfall form numerous triangles that point to the focal point. This painting needs many eye stoppers and fillers because of the complexity of its composition.

### Third Triangle-Shape Composition
This is an example of another type of triangle-shape composition. The fillers and eye stoppers actually form the shape of the triangle and the center of interest is located within the triangle. The eye follows the triangle eye flow created by the dead tree, tepees and the stump.

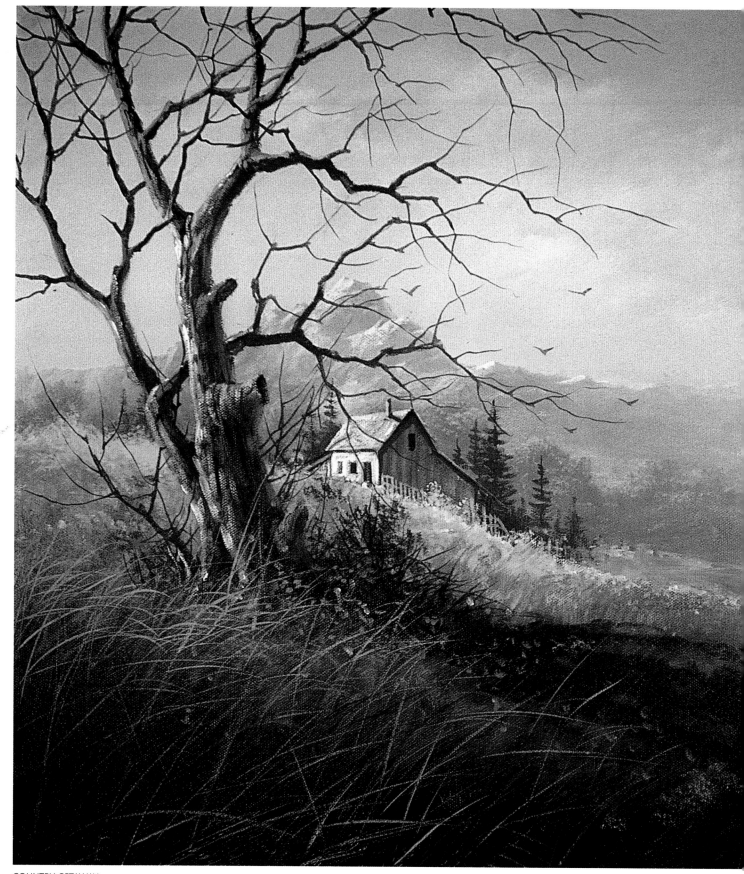

COUNTRY GETAWAY
16" x 20" (41cm x 51cm)

# Country Getaway

*This painting is a simple L-shape compositions. You can use an L-shape for a straightforward landscape, with few subjects or objects. In this case, the center of interest is crucial to eye flow. For example, the large tree to the left is the main element that leads the eye through the composition. Additional elements used in the painting also must fall within the L-shape eye flow. The cabin, mountain peaks and pine trees all fall within this shape. Other fillers like the weeds, flowers and miscellaneous bushes help fill out the landscape.*

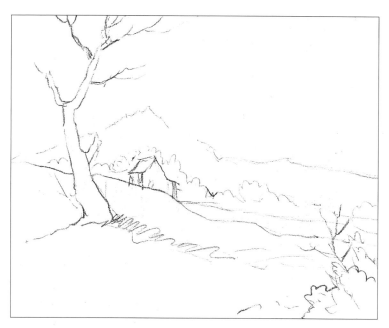

## 1 Basic Sketch

Begin with a basic sketch of the main components of the composition, using a piece of no. 2 soft vine charcoal.

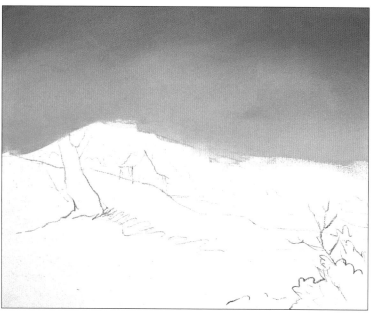

## 2 Underpaint Sky

Wet the sky area with a hake brush, then apply a liberal coat of gesso. While the gesso is still wet and with the same brush, begin at the horizon and paint a small amount of Cadmium Orange and a touch of Cadmium Yellow Light directly onto the canvas. At the top, paint half of the sky with Ultramarine Blue, Dioxazine Purple and a touch of Burnt Sienna. Paint downward until you meet the other color. Rinse your brush. Paint feathery brushstrokes by crosshatching the sky area. Blend the two color mixtures on the canvas until the sky is soft and hazy.

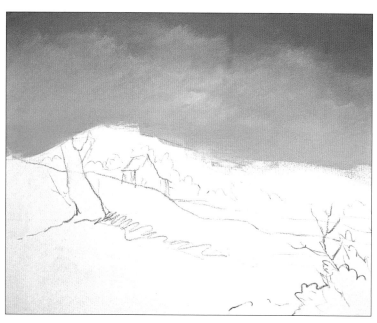

## 3 Add Clouds

Keep the clouds soft and simple. Mix Titanium White with a dab of Cadmium Orange until the mixture is slightly tinted. With a no. 6 flat bristle brush, rough in the clouds. Make the clouds soft, adding just enough of them for interest and atmosphere. Remember, there should be no hard edges.

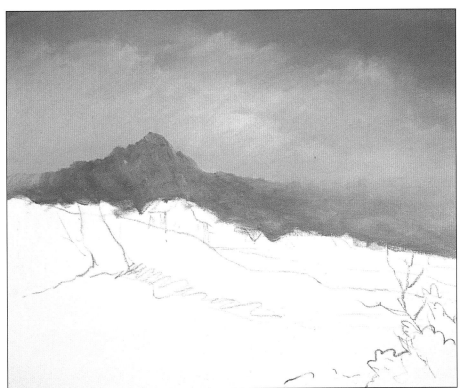

# 4 Block in Background Mountains

The mountain is an important element in the painting but must not compete with the center of interest. Place the main peak within the L-shape eye flow. For the color of the mountain, mix Titanium White with a touch of Ultramarine Blue, Burnt Sienna and a small amount of Dioxazine Purple. Adjust the value so that the mountain is slightly darker than the sky. With a no. 6 flat bristle brush, block in the mountain, creating interesting negative space. Blend the right side of the mountain, gradually fading it out. Continue to blend away the hard edges.

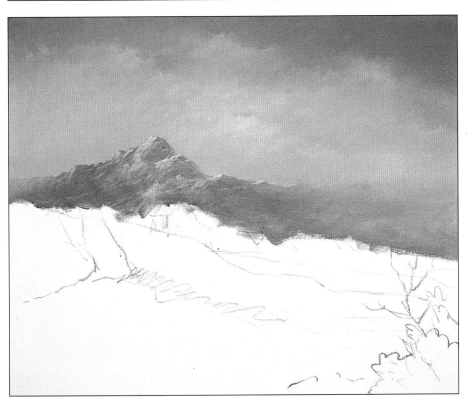

# 5 Highlight Mountain

Mix Titanium White with just enough Cadmium Orange to make a warm, off-white tone. With a no. 4 round sable brush, layer the highlights, beginning with the right side of the mountain. Concentrate the highlights on this side first because the sunlight is coming in from the left. Make the highlights brighter at the top of the mountain and gradually fade them to the base.

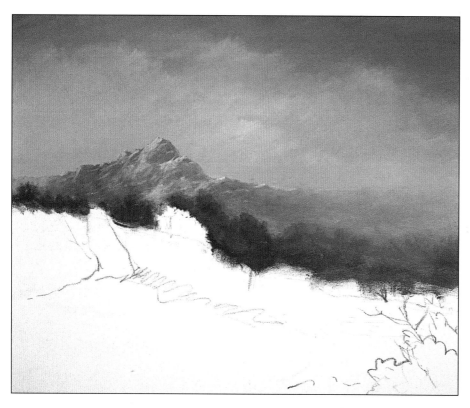

## 6 Underpaint Background Trees

The trees create depth in this composition. Fade the trees from right to left to keep the viewer's eye from leaving the canvas. Place the trees within the L shape that you have already set up in step 4. Mix Titanium White with a touch of Hooker's Green and Dioxazine Purple. Add a touch of Burnt Sienna to warm up the mixture. With a no. 6 flat bristle brush, paint the trees with light, feathery brushstrokes. Keep the edges soft.

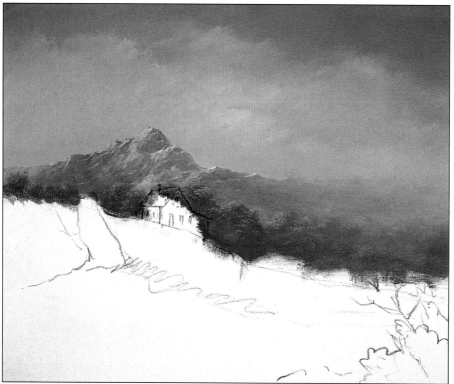

## 7 Highlight Background Trees and Sketch Cabin

For the tree highlights, mix Thalo Yellow Green with a touch of Cadmium Orange and Titanium White. To give the trees more character, gently paint in highlights with a no. 6 flat bristle brush. The highlights should not be too bright because the trees are in the background. Sketch in the cabin with a piece of no. 2 soft vine charcoal.

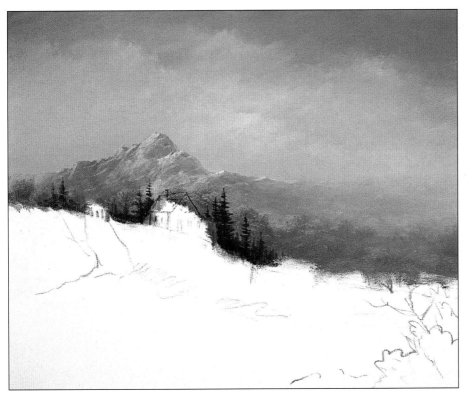

## 8 Block in Pine Trees

Place the pine trees behind the cabin so that they are well within the L-shape eye flow. Mix Hooker's Green, Dioxazine Purple and a touch of Burnt Sienna. Use Titanium White to lighten the value accordingly. Paint in the trees with a no. 4 flat bristle brush. A no. 4 round sable brush will work just as well but be careful not to add too much detail with this brush. Lightly paint in the shape of the pine trees. Make interesting negative space.

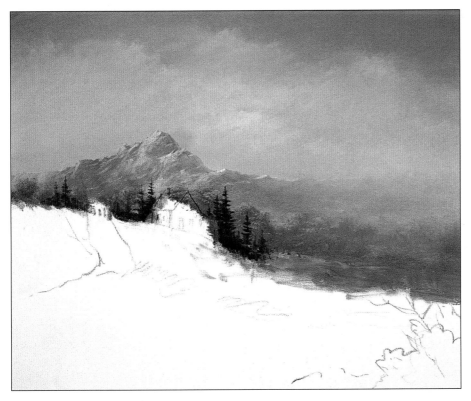

## 9 Block in Background Meadow

For this short step, mix Hooker's Green, Titanium White and a touch of Cadmium Orange with a no. 6 flat bristle brush. Do not mix the colors on the palette. Pick them up individually and mix them together directly on the canvas. Make adjustments to the value and color as you go.

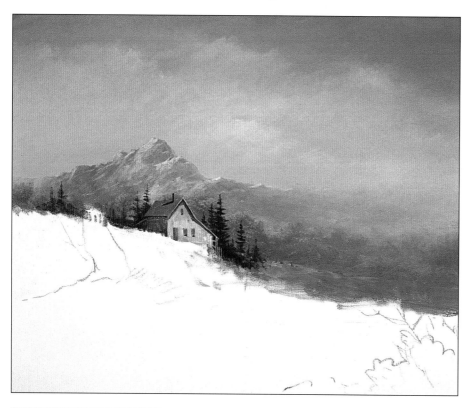

# 10 Underpaint Cabin

For the cabin, mix a gray tone using Titanium White, Burnt Sienna, Ultramarine Blue and a touch of Dioxazine Purple. Mix the colors to a medium-dark value. Adjust the mixture to fit the values in your own painting. Paint the dark side of the cabin with a no. 4 round sable brush. Lighten the mixture with a dab of Titanium White and paint the light side of the cabin. Make sure the cabin is in correct proportion and that all of the edges meet at right angles.

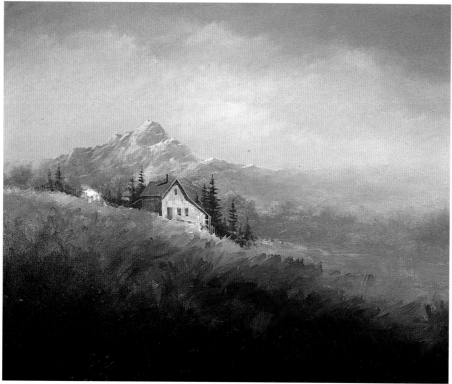

# 11 Underpaint Middle and Foreground Grass

For this fun step, paint quickly using lots of thick paint. Use a no. 10 flat bristle brush for the entire process. Beginning at the top of the hill, paint a thick layer of Thalo Yellow Green and a small amount of Cadmium Orange directly on the canvas. Paint a wide stripe across the horizon. Add a touch of Hooker's Green, Burnt Sienna and Dioxazine Purple to the same mixture. Mix these colors directly onto the canvas, adding them gradually. Darken the colors as you move from the background to the foreground. At this stage, you should have several rows of colors. Lay your no. 10 flat bristle brush against the canvas and pull the colors upward to the top of the hill. Paint additional rows until all the colors are blended together, giving the impression of texture.

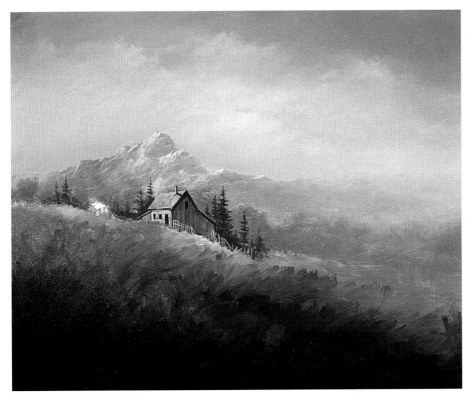

## 12 Repaint Cabin

Guess what? I made a mistake. Did you catch it? I painted the cabin in step 10 with the sun coming in from the right instead of from the left. Mix a small amount of Titanium White, Burnt Sienna, Ultramarine Blue and a touch of Dioxazine Purple. With no. 4 round sable brush correct this mistake, reversing the shadow and the highlight. Since the cabin has very little detail, take this opportunity to finish painting the cabin.

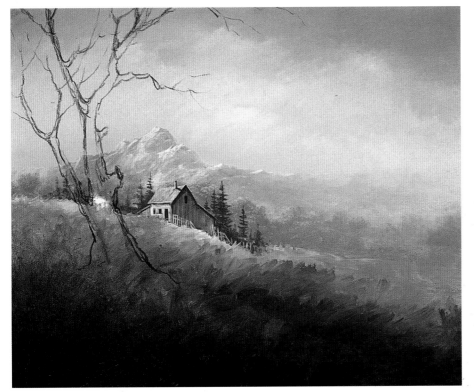

## 13 Sketch Main Tree

Roughly sketch in the main tree trunk and branches. In this step, you can work out any proportional problems, along with any negative space issues. Refer to *pages 20 and 21* for information regarding the negative space rule. Use a piece of no. 2 soft vine charcoal to complete the sketch and make corrections with a damp paper towel.

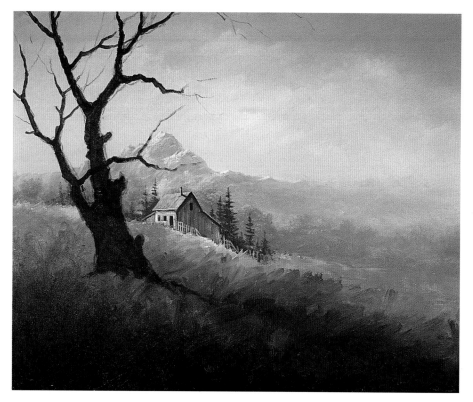

## 14 Underpaint Main Tree

Mix Ultramarine Blue, Burnt Sienna and a small amount of Dioxazine Purple. Block in the tree with a no. 6 flat bristle brush, mixing all of the colors directly onto the canvas. In this step you can mix the paint fairly thick. Switch to a no. 4 round or flat sable brush to paint the intermediate limbs. Leave out the smaller limbs because you will be adding them in a later step.

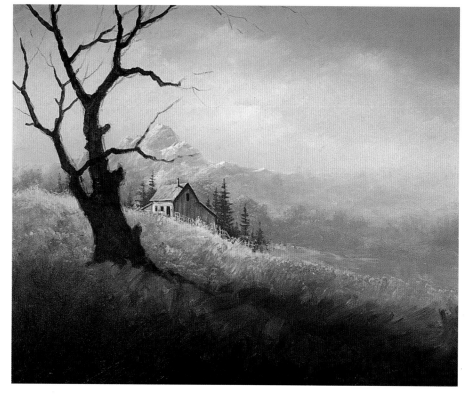

## 15 Highlight Middle Ground Grass

To add highlights to the grass, mix Thalo Yellow Green with a small amount of Cadmium Yellow and Titanium White. Paint in the highlights with a no. 10 flat bristle brush. Select areas that will add interest to your painting. Suggest small bushes and distant flowers with light, quick brushstrokes. Scatter the highlights throughout the middle ground.

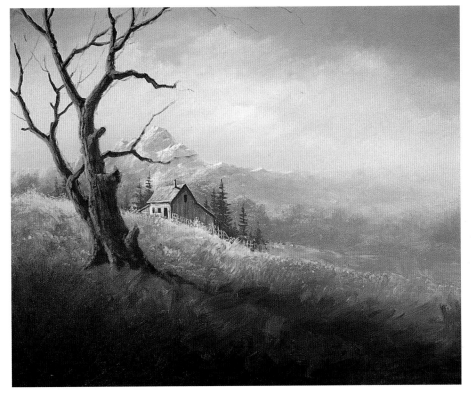

**16** **Highlight Tree**
Mix Titanium White with a hint of Cadmium Orange. Paint the bark with short vertical brushstrokes with a no. 4 flat sable brush. Enhance the texture even more by allowing some of the background to show through. Don't add too many highlights. In a few places, change the tone of the highlights by adding small amounts of Cadmium Orange.

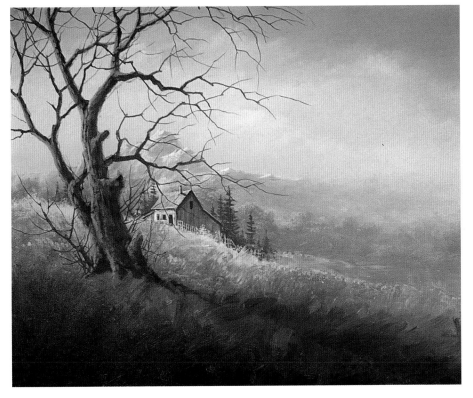

**17** **Add Tree Limbs**
This step may be difficult, but practice does make perfect. Practice this step first on a scrap of canvas. Mix Burnt Sienna, Ultramarine Blue and a small amount of Dioxazine Purple. Thin this mixture with water until it is the consistency of ink. Roll your no. 4 script liner through the color until the end becomes a point. Drag your brush from the trunk towards the center, overlapping the limbs with a light touch.

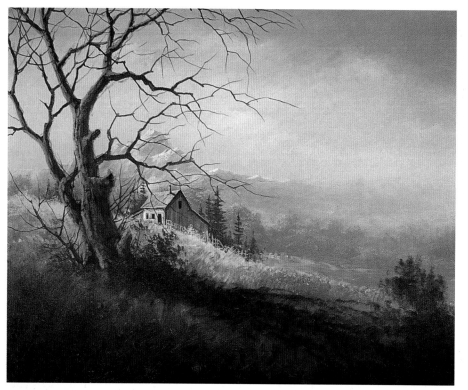

## 18 Add Tree Shadows and Bushes

Paint in the shadow of the dead tree using a no. 6 flat bristle brush and a mixture of Hooker's Green, Burnt Sienna and a small amount of Dioxazine Purple. Paint the shadow with vertical brushstrokes, following the contour of the hillside and the direction of the grass. Block in the bushes with the same mixture. The bushes should not interfere with the eye flow or the center of interest.

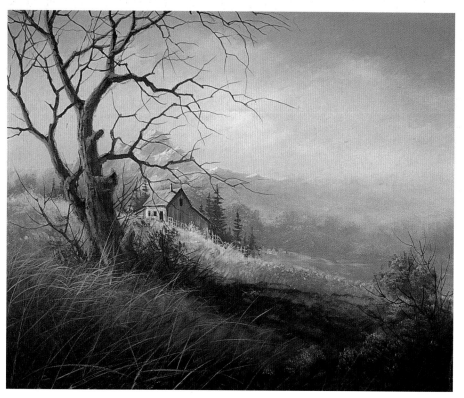

## 19 Add Details to the Foreground

This step provides a number of opportunities to be creative. Start with an inky mixture of Thalo Yellow mixed with Hooker's Green and Titanium White. Add the weeds in the foreground with a no. 4 script liner. Paint in the tree limbs and add some dead bushes and darker weeds with the same mixture. Next, load a middle-value green onto the bushes with a no. 6 flat bristle brush. Finish by embellishing the scene with a few flowers.

# 20 Final Details and Highlights

It is not unusual to be satisfied with the painting at this point. Nevertheless, it is a good idea to stand back and study it from a distance. Adjust the highlights by making some darker or lighter than others. Add more flowers or bring out a few more details in the cabin. For a final touch, use a no. 4 flat sable brush to add a reflective highlight to the left side of the tree. Mix Ultramarine Blue, Dioxazine Purple and Titanium White and drybrush the back side of the tree. For this last step, remember to accentuate the L-shape in the composition.

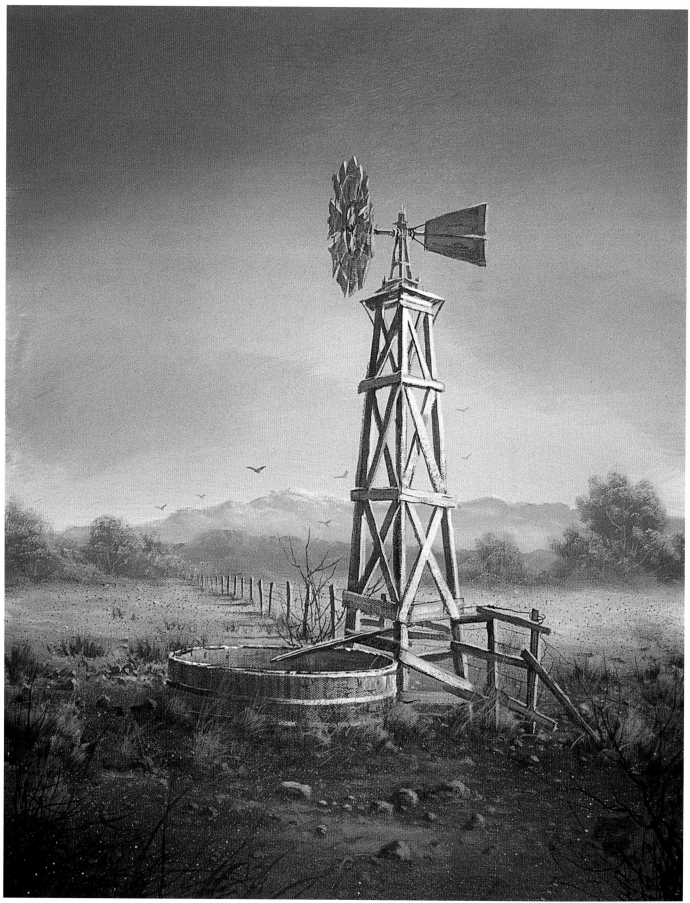

PRAIRIE RELIC
16" x 20" (41cm x 51cm)

# Prairie Relic

*Here, we have another L-shape composition. The windmill and water tank are strong images that form the entire L-shape eye flow. Several fillers, like the distant hills and trees, help fill out the composition. Clumps of grass, rocks and pebbles complete the middle and foreground and the dead bushes and the tall weeds work as eye stoppers. Now it is time to get to work, so let's get started.*

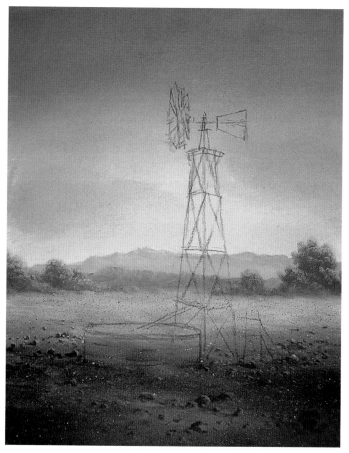

### 9 Underpaint Rocks

Paint the many small rocks scattered throughout the middle and foreground with a no. 4 flat sable brush. Mix Burnt Sienna with a touch of Ultramarine Blue and Dioxazine Purple. Block in several rocks, beginning at the windmill and coming into the foreground. Don't let these rocks get too dark in your painting. If they do, lighten them with a little Titanium White. Keep the values consistent.

### 10 Highlight Rocks

Mix Burnt Sienna with a touch of Ultramarine Blue and Dioxazine Purple. Add Titanium White and a touch of Cadmium Orange to this mixture. Load a small amount onto your brush and drybrush each rock with a no. 4 flat sable brush. Switch to a no. 4 round sable brush for the smaller rocks. Keep the highlights subtle.

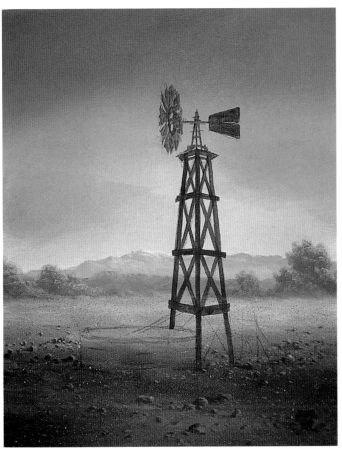

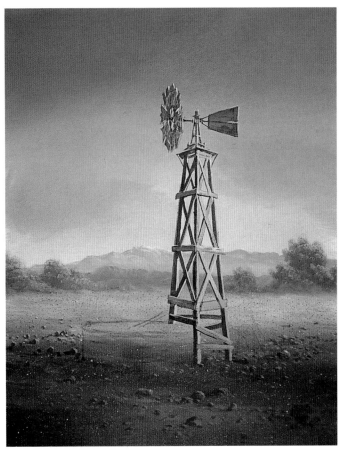

**11** **Underpaint Windmill**
This step is very difficult, but with a little practice you can do it. Mix Burnt Sienna, Ultramarine Blue and a little Titanium White until the mixture is creamy. Block in the windmill with a no. 4 round sable brush. To keep your hand steady, use a mahl stick and a stedi-rest system. To see how to use this gadget, refer to book 3 of this series.

**12** **Highlight Windmill**
Mix Titanium White with a touch of Cadmium Orange and a small amount of the mixture used in step 11. Mix the colors until they are a creamy consistency. Add the highlights to the right side of the windmill and any other hard edges that require a highlight with a no. 4 flat or no. 4 round sable. Brighten this highlight later.

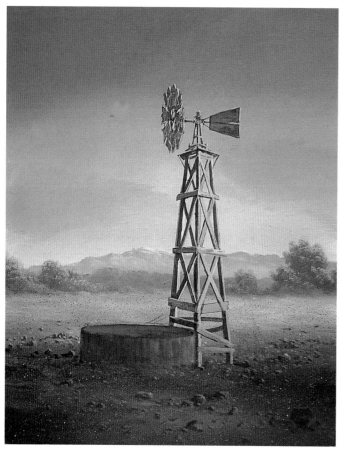 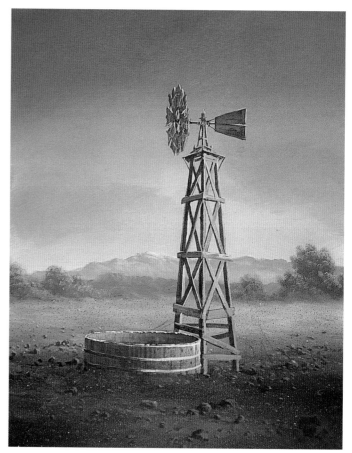

**13** **Underpaint Water Tank**
Paint the water tank in three different values. Mix the base value to a dark gray with Burnt Sienna, Ultramarine Blue and a little Titanium White. Paint the shadow of the tank with a no. 4 flat bristle brush. Suggest boards by painting single vertical brushstrokes from the top to the bottom of the tank. Continue blocking in the water tank, adding more Titanium White as needed for the lighter values.

**14** **Highlight Water Tank**
Mix Titanium White with a touch of Cadmium Orange. Drybrush the highlight with a no. 4 flat sable brush, using vertical brushstrokes. Gradually fade the color into the shadow of the water tank. Paint the highlight at the top of the tank with a no. 4 round sable brush. Add the band around the tank.

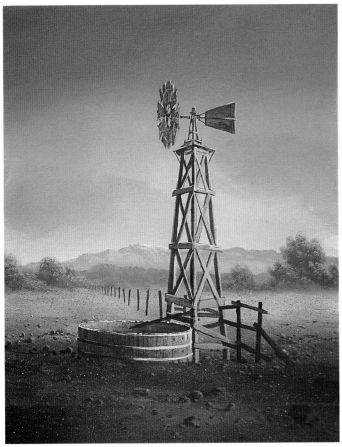

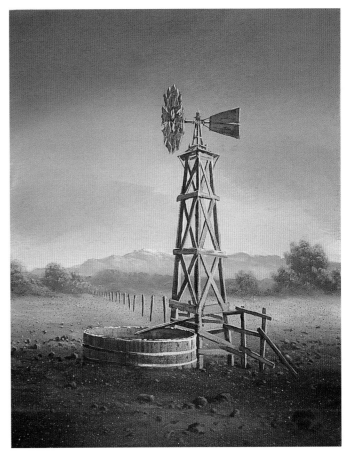

**15** **Underpaint Fence and Miscellaneous Items**
Mix Burnt Sienna, Ultramarine Blue and a little Titanium White for this step. Underpaint the fence and any other boards with a no. 4 round or flat sable brush. Lighten the value of the fence as it recedes into the distance. Adjust the proportions and location of other objects so that they stay well within the L-shape eye flow.

**16** **Highlight Fence**
This is a very simple and quick step. Mix Titanium White with a touch of Cadmium Orange. Highlight the fence posts with a no. 4 round sable brush. Brighten this highlight by adding a touch more of Titanium White. Repeat the process two or three times or until the value matches the surrounding area.

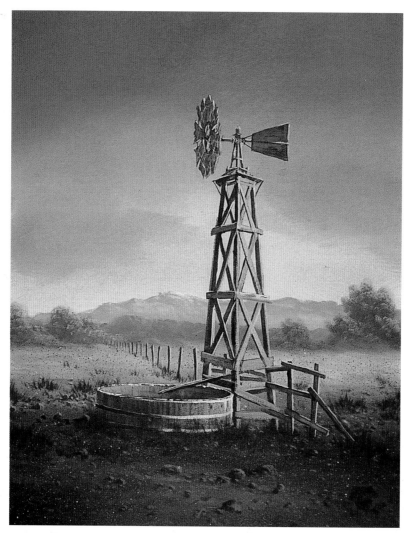

# 17 Add Clumps Of Grass

The clumps of grass are an important fillers for this painting. Mix Hooker's Green with Dioxazine Purple and a small amount Titanium White. Apply the grayish-green mixture with a no. 6 flat bristle brush. Carefully plan the location of each clump, using the overlap rule. Drybrush in the basic shape. The placement of the grass should not compete with the L-shape eye flow or center of interest. Adjust the value according to the location of the grass in the painting.

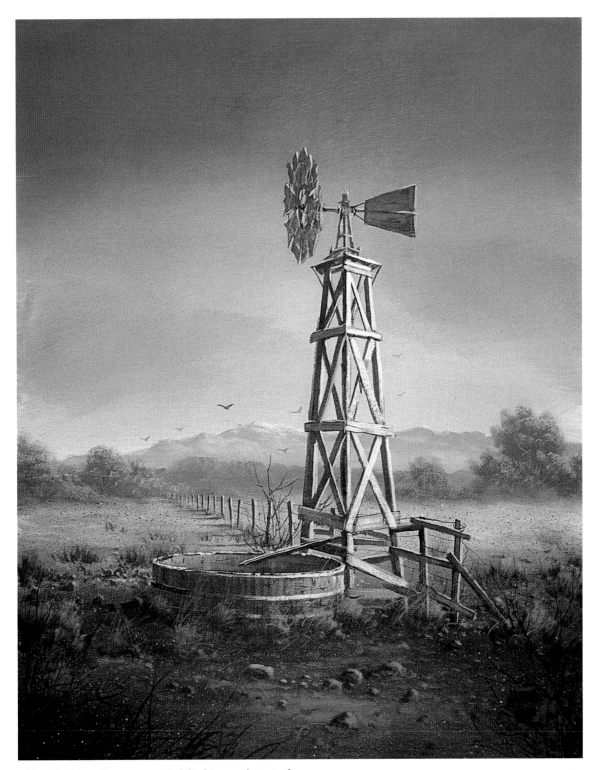

# 18 Miscellaneous Highlights and Details

For this step, paint in all of the details and highlights that will give the painting its snap. Add the dead bushes in the corners as eye stoppers. Brighten the highlights on some of the rocks and on the windmill and the tank. Highlight the wire on the fence. Paint the wire and dead bushes with a no. 4 script liner brush and a dark inky mixture of Burnt Sienna and Ultramarine Blue. Mix Thalo Yellow Green and a touch of Cadmium Orange and paint the highlights on the grass. Have fun, but don't overdo it!

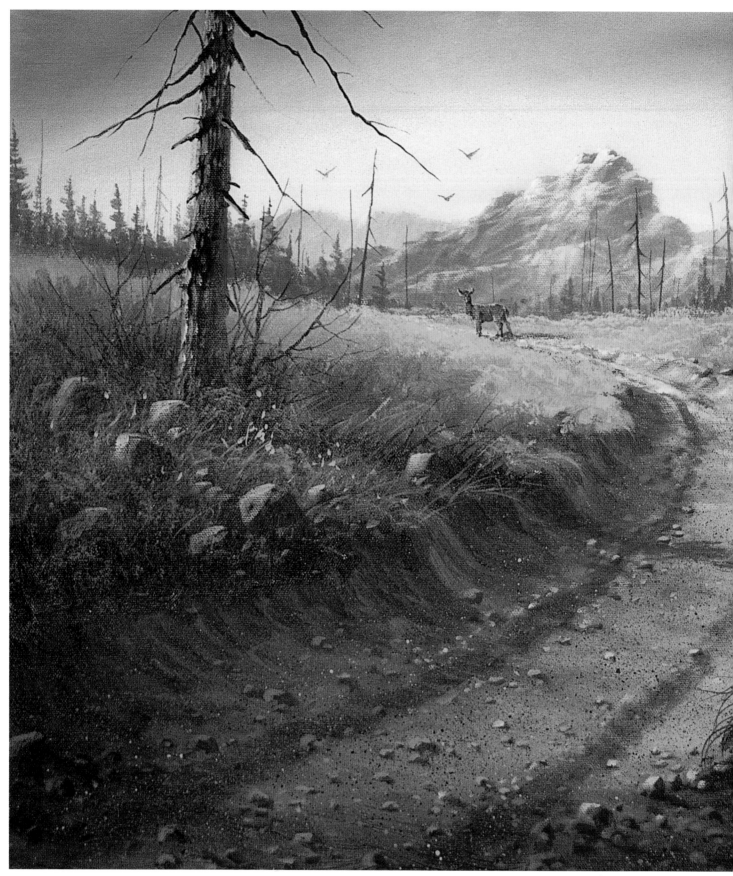

ROCKY ROAD
16" x 20" (41cm x 51cm)

# Rocky Road

*Unlike an L-shape composition, a triangle-shape compositions may have many different elements present that can effect eye flow. In this painting, the deer is center of interest and the other objects like the pine trees, are arranged to lead your eye to the deer. If you look closely, many of the elements such as, fillers and eye stoppers, suggest triangles. Now that you get the idea of what a basic triangle-shape composition is, let's get started!*

## 1 Basic Sketch
Make a rough sketch with a piece of no. 2 soft vine charcoal of the basic landscape elements.

## 2 Underpaint Sky
Wet the sky area and apply a liberal coat of gesso with a hake brush. While the gesso is still wet, paint Cadmium Yellow Light onto the horizon and blend it halfway up the canvas. Rinse your brush. Next, paint Ultramarine Blue at the top of the canvas and blend it downward until you meet the area that you painted Cadmium Yellow. Rinse your brush again and feather the two colors together with a criss-cross brushstroke.

## 3 Underpaint Background Mountains

The distant mountains give the painting depth. Mix Titanium White with a little Dioxazine Purple, a touch of Burnt Sienna and a very small amount of Ultramarine Blue. The mixture should have a purple tone with a value that is slightly darker than the sky. Paint in the shape of the mountains with a no. 6 flat bristle brush. Keep the shapes soft and simple.

## 4 Underpaint Large Mountain

This step is identical to step 3, except for the color value. Darken the mixture used in step 3 by adding Dioxazine Purple, Burnt Sienna and Ultramarine Blue. I like to use my no. 6 flat bristle brush for this step. Paint in the mountain, giving it a unique shape. Cover the canvas well, keeping the edges of the mountain soft.

**5** **Highlight Large Mountain**
Mix Titanium White with a touch of Cadmium Yellow and a small amount of Cadmium Orange. Highlight the mountain with a no. 4 flat sable brush. Use a small amount of the mixture to complete this step. Paint the highlight from right to left. Keep the highlight soft and hazy to suggest sunlight.

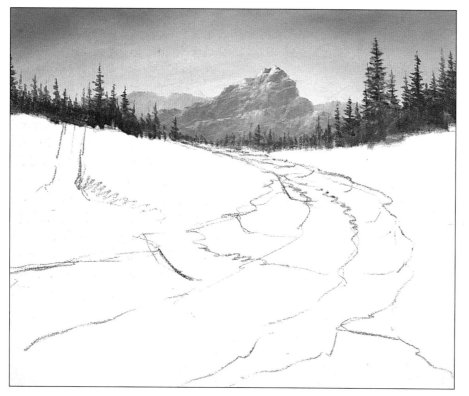

**6** **Underpaint Distant Pine Trees**
If you have painted with me even for a short time, you have probably painted dozens of pine trees by now. Mix Hooker's Green, Titanium White, Dioxazine Purple and a touch of Burnt Sienna until the mixture becomes a greenish gray. Adjust the value until it is about two shades darker than the mountain. Paint a nice collection of trees on each side of the canvas with a no. 6 flat bristle brush. Paint more trees on the right than on the left.

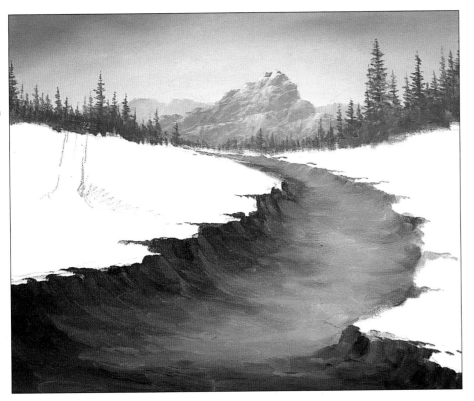

## 7 Underpaint Road

For this easy step, mix Burnt Sienna and Dioxazine Purple. Mix a second mixture of Titanium White and a small amount of Cadmium Orange and Cadmium Yellow Light. Paint in the dark side of the road with a no. 6 flat bristle brush. Paint in the sunlit side of the road with the light mixture in short, choppy horizontal strokes to suggest dirt. Blend the two values together in make a third value in the center of the road. Cover the canvas well.

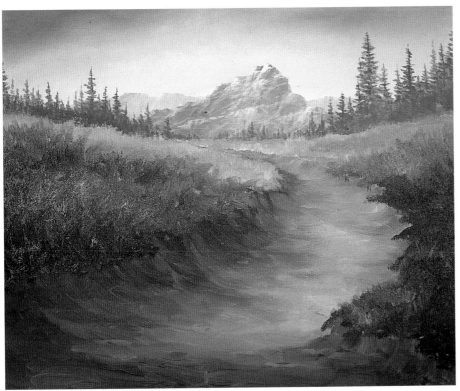

## 8 Underpaint Meadows

This is a very impressionistic step and a lot of fun to do. Use a no. 10 flat bristle brush to apply a thick mixture of Thalo Yellow Green and a little Cadmium Orange to the top of one of the hills. Darken the mixture with Hooker's Green, Dioxazine Purple and Burnt Sienna. Paint the mixture just below the one you just finished. Don't mix the colors too much, but push them downward, holding the brush flat against the canvas. Continue pushing the colors down in rows until they begin to blend. Keep the grass light, airy and textured.

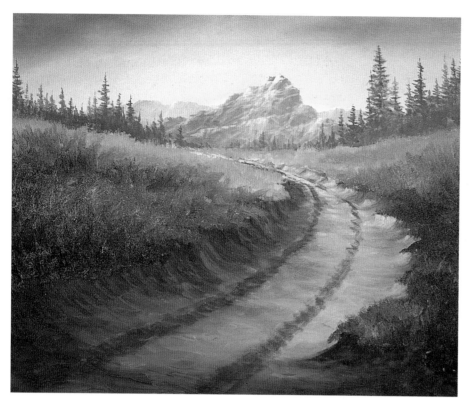

## 9 Detail the Road

In this step you will add ruts and highlights to the road. Mix Titanium White and a touch of Cadmium Orange. Highlight the road with a no. 6 flat bristle brush. Paint the side of the road with short, choppy brushstrokes to suggest an eroded bank. Do the same on the shadow side. Blend both values with short horizontal brushstrokes. Darken the mixture with a touch of Ultramarine Blue, Burnt Sienna and Dioxazine Purple. Drybrush the ruts with a no. 6 bristle brush, keeping the shadows lighter in the background and darker in the foreground.

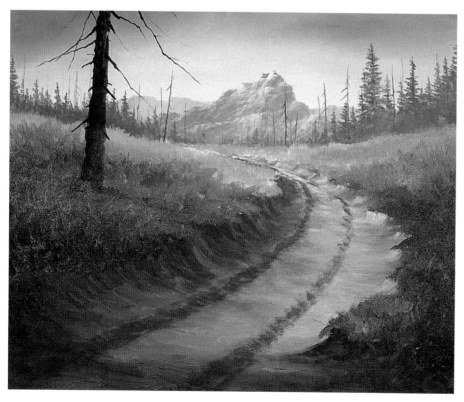

## 10 Underpaint Dead Pine Trees

For this step, begin with the pine trees in the background. Mix Burnt Sienna with a touch of Ultramarine Blue and Titanium White. Adjust the value of this color to fit the value of the surrounding area. Thin the mixture and paint several small dead pine trees with a no. 4 script liner brush. Mix Burnt Sienna, a touch of Dioxazine Purple and Ultramarine Blue and block in the large pines with a no. 6 flat bristle brush. Use short, choppy, vertical brushstrokes to give the trees a light texture. Finish the trees by adding the limbs with a no. 4 script liner brush.

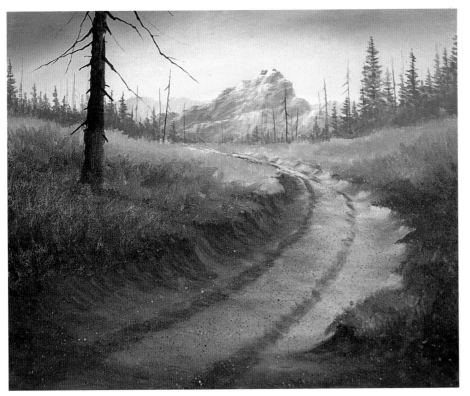

## 11 Add Pebbles with Toothbrush

You have probably done this fun technique before. Use any colors you want as long as you use a good range of lights and darks. Thin Burnt Umber, Burnt Sienna and Ultramarine Blue for your dark colors. Thin Cadmium Yellow Light, and Cadmium Orange and Cadmium Red Light for your light colors. Add a touch of Titanium White to make the light colors a little opaque. Load the paint onto your toothbrush and splatter each color separately until the road is covered. Cover this area well.

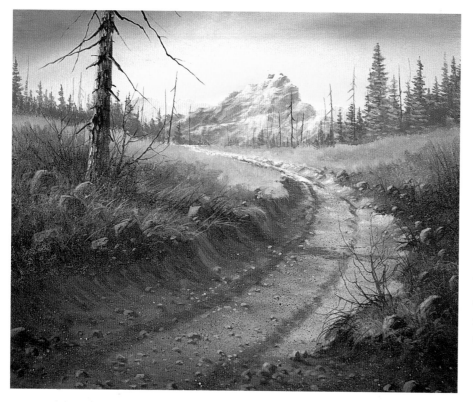

## 15 Add Miscellaneous Details

Your no. 4 script liner brush will get quite a workout in this step. Mix a dark value with Hooker's Green, Burnt Sienna and a small amount of Dioxazine Purple for the tall dark weeds. Thin this mixture until it is the consistency of ink. Paint in the tall dark weeds. Mix Thalo Yellow Green and Cadmium Orange or Cadmium Yellow and Cadmium Orange. Thin the mixture and paint in the lighter weeds. Thin a mixture of Burnt Sienna and Ultramarine Blue to paint in the dead bushes. These elements are very important eye stoppers so don't be afraid to make a bold statement.

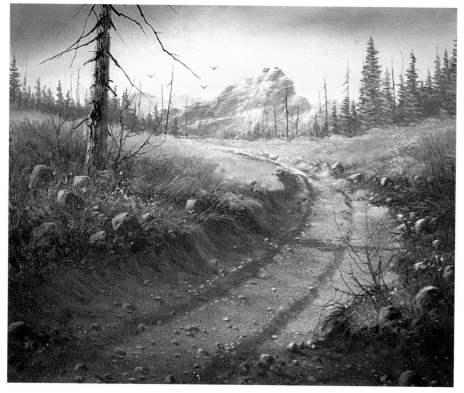

## 16 Final Highlights and Flowers

Let your imagination and artistic license take over here, but be careful not to overdo it. Now it's time to add the flowers and brighten the highlights on the rocks and dead pine trees. Study the overall values in your painting and have some fun with them. Apply these final highlights, so that your painting has continuity. You will know if you overdo it. If so, simply tone it down.

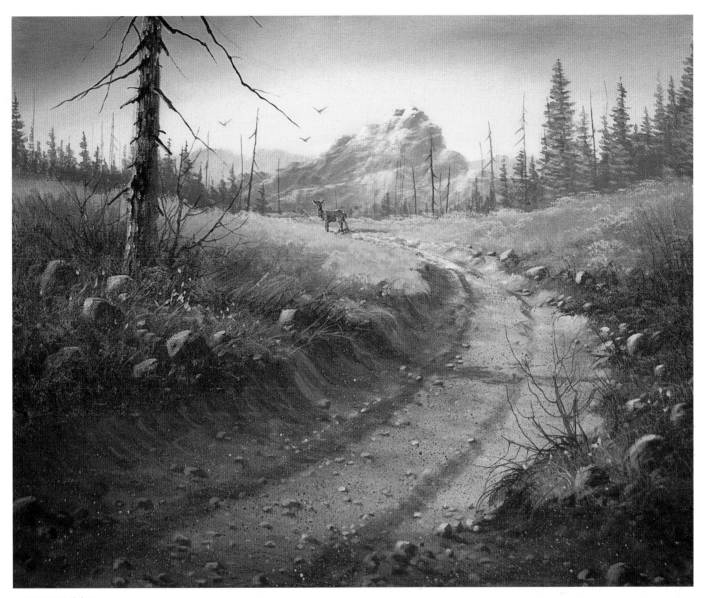

# 17 Add Deer

You can use any subject you like here, but remember to place your subject within the main eye flow of the triangle. A deer is a good choice because it is a simple subject to use and works well in a triangle-shape composition. In this case, the deer is located where all of the triangles merge. The deer must be placed within the main eye flow of the painting. To underpaint the deer, mix Titanium White with Burnt Sienna and a touch of Ultramarine Blue. Block in the basic shape with a no. 4 flat or round sable brush. Paint the highlights with a mixture of Titanium White and Cadmium Orange. Add shadows with a no. 4 round sable brush.

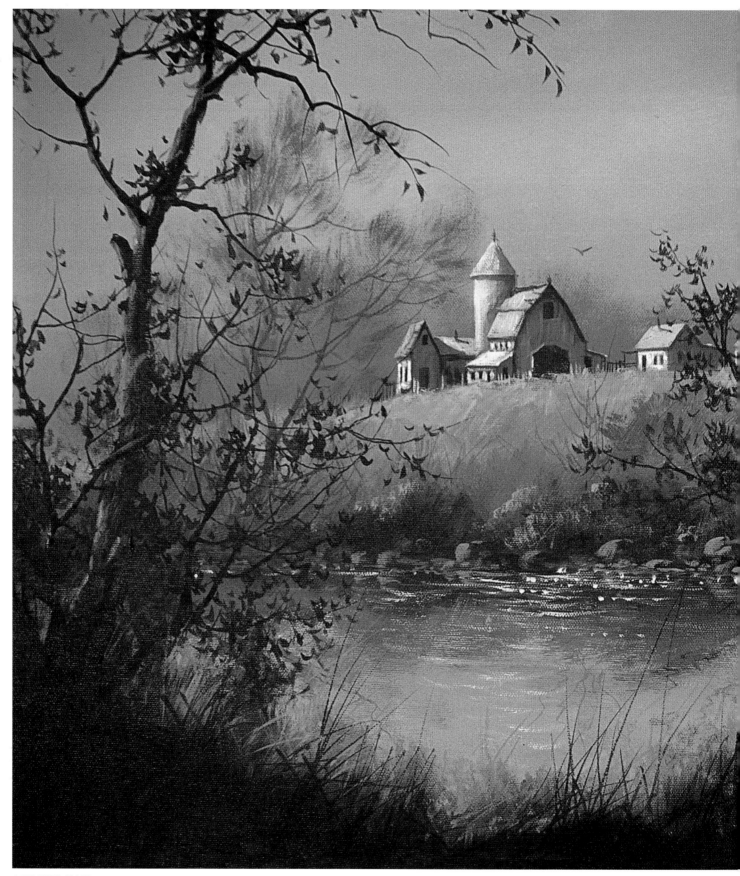

A PEACEFUL PLACE
16" x 20" (41cm x 51cm)

# A Peaceful Place

*The farm buildings are the center of interest in this painting. However, this composition is a little different because there are no ground formations, mountains, or other fillers used to lead your eye to the center of interest. I had to find a way keep the focus on the main subject, so I chose to use large trees in the foreground to form a window into the painting. This window suggests a single triangle with the center of interest in the middle. The fillers I used are the water, grass, rocks, weeds and leaves.*

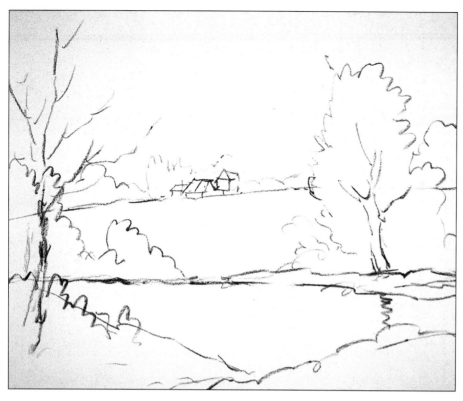

## 1 Basic Sketch

Sketch the basic elements of the composition and the contours of the landscape with a piece of no. 2 soft vine charcoal.

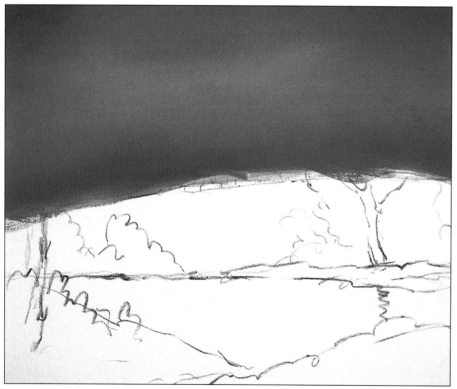

## 2 Paint Sky

Wet the sky area and then apply a liberal coat of gesso with a hake brush. While the gesso is still wet, paint pure Dioxazine Purple onto the horizon and blend the color halfway up the canvas. Next, paint pure Ultramarine Blue at the top and blend downward until you meet the Dioxazine Purple area. Rinse your brush. Paint large, feathery brush-strokes across the sky, blending the two colors together.

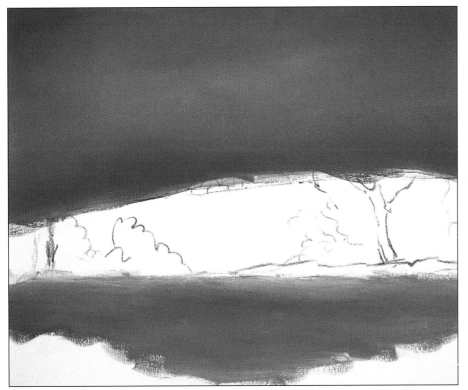

# 3 Underpaint Water

Repeat the same blending technique that you used in step 2, altering it slightly. In this step you switch the colors. The Dioxazine Purple tone is at the top of the water area and the Ultramarine Blue is at the bottom. Notice that I painted the water area larger than I did in the sketch. This is because the water area will shrink when you add the grass.

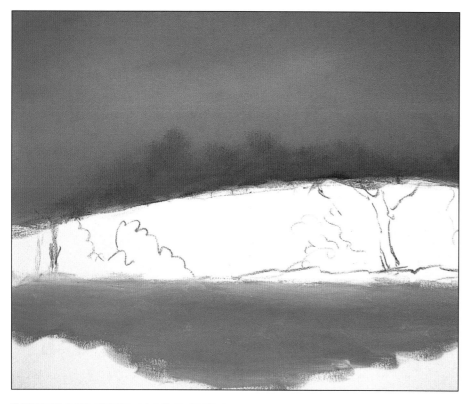

**4 Underpaint Background Trees**
Keep the trees soft and simple so that you can add depth to your painting. Mix Titanium White with Hooker's Green and Dioxazine Purple. Adjust this mixture until the color is slightly darker and more purple than the sky. Paint the trees into the background with a no. 6 flat bristle brush. Blend well and keep the edges soft.

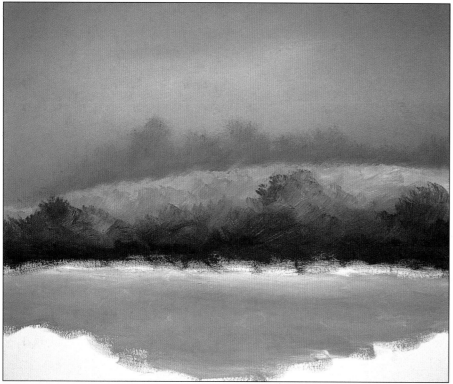

**5 Underpaint Hillside**
This hill doesn't need a lot of detail because it divides the background and the foreground. However, it does need three values. Mix Titanium White with a touch of Thalo Yellow Green, Cadmium Orange and Hooker's Green. Paint on a thick layer of this mixture to the top of the hillside with a no. 10 flat bristle brush. Darken the value by adding more Hooker's Green and Dioxazine Purple until the mixture is fairly dark at the water's edge. While these colors are still wet, with a no. 10 flat bristle brush, push the colors upwards until each layer runs together.

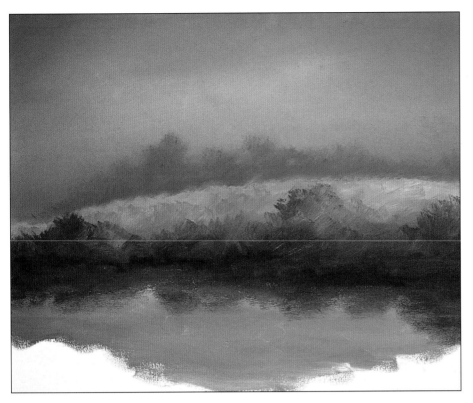

### 6 Underpaint Reflections

Mix a soft greenish gray using Titanium White, Hooker's Green and a touch of Dioxazine Purple. Thin the mixture with water until it is a creamy consistency. Paint the first layer of reflections with a small amount of this mixture and a no. 6 flat bristle brush. Blend the edges well.

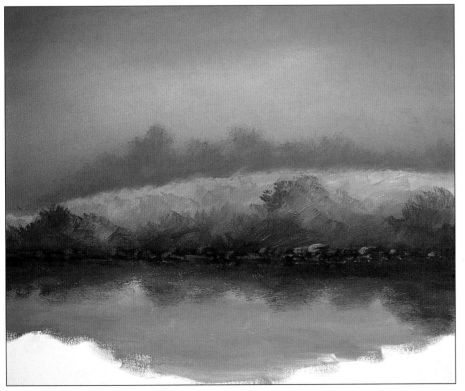

### 7 Paint Shoreline

This is a fun step because the little details begin to appear. Mix Hooker's Green, Burnt Sienna and Dioxazine Purple until fairly dark. Paint this color along the shoreline in short, choppy brushstrokes with a no. 6 flat bristle brush. Avoid painting a hard straight line. Add details by suggesting bushes above the water's edge. Next, add a little Titanium White and Cadmium Orange to the mixture. Paint in a few rocks or rough areas for an interesting shoreline.

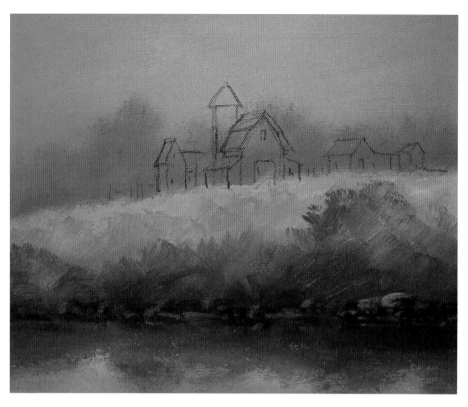

## 8 Sketch In Buildings

Sketch in the buildings with a piece of no. 2 soft vine charcoal. Keep the sketch rough, but correctly work out the proportions and perspective of the buildings.

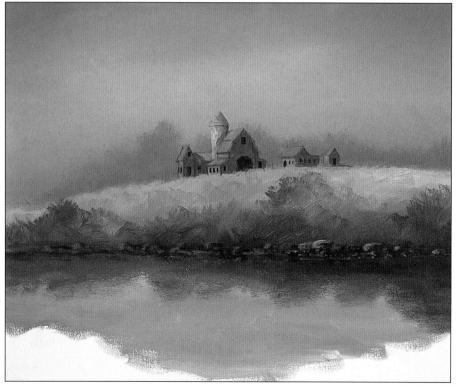

## 9 Underpaint Buildings

Mix a soft gray with Titanium White, a small amount of Ultramarine Blue and a touch of Burnt Sienna. Adjust the value to match the rest of this area in your painting. Block in the shadows of the buildings with a no. 4 flat sable. Add more Titanium White and a touch of Cadmium Orange to the gray mixture. Block in all of the light sides of the buildings. Adjust the shapes that you have just blocked in.

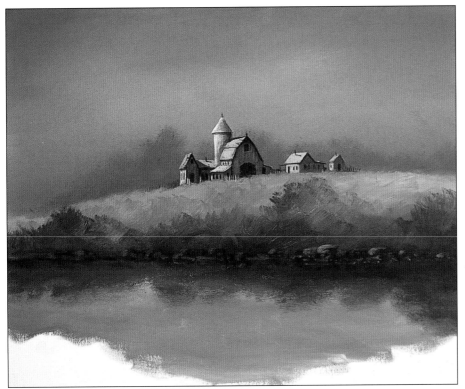

**10 Detail Buildings**
Use your artistic license in this step. Mix a shadow color with Ultramarine Blue, Burnt Sienna and Dioxazine Purple. Move or adjust the location of the doors and windows. Add all of the overhanging shadows on the roofs. For the highlights, mix Titanium White with a touch of Cadmium Yellow. With a no. 4 round and flat sable and a script liner brush, brighten the highlighted areas. Drybrush a small amount on the dark side of the buildings to suggest weathered wood.

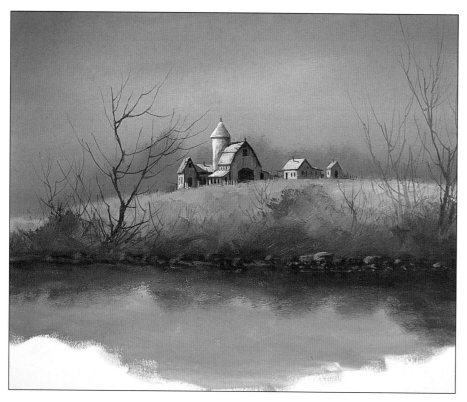

## 11 Add Foreground Tree Limbs

Mix a medium gray color with Titanium White, Burnt Sienna and Ultramarine Blue. Adjust the value of this mixture to match the area just above the water's edge and then thin the mixture until it is the consistency of ink. Paint the tree trunks with a no. 4 script liner brush. Avoid making these trees too dark or too large. Surround the center of interest with them.

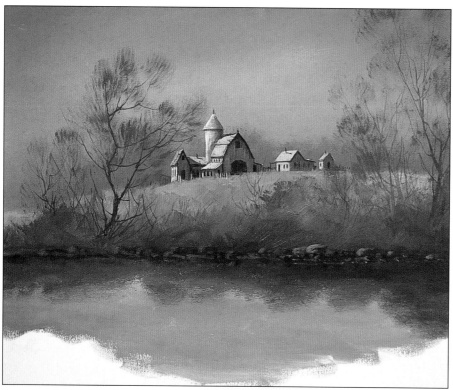

## 12 Drybrush Leaves on Limbs

Mix Hooker's Green, Titanium White and Cadmium Orange until the mixture is a soft olive green. Drybrush scattered leaves with a no. 10 flat bristle brush. Leave some patches of sky showing through so that the trees aren't too overwhelming. Use interesting negative space.

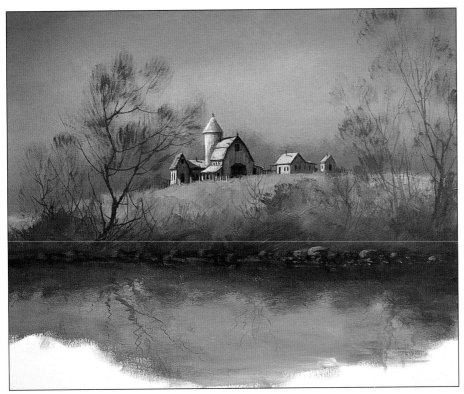

## 13 Paint Final Reflections

For this step, mix a dark olive green color by mixing Hooker's Green, Burnt Sienna and a small amount of Cadmium Orange. Paint in the darker value with a no. 6 flat bristle brush. Paint in the bushes just above the water's edge. Keep the edges soft.

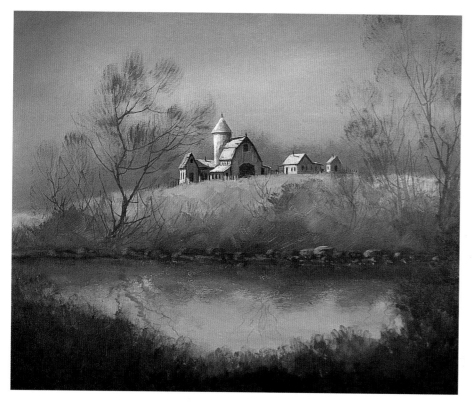

## 14 Paint Foreground Grass

For the grass, mix Thalo Yellow Green with a little Cadmium Orange and Cadmium Yellow Light. Paint this mixture in an irregular shape along the water's edge with a no. 10 flat bristle brush. Push the color upward along the edge to form clumps of grass. While this area is still wet, mix Hooker's Green, Burnt Sienna and Dioxazine Purple. Paint this mixture fairly thick along the bottom of the canvas. Place the flat of your brush against the canvas and push this color into the grass.

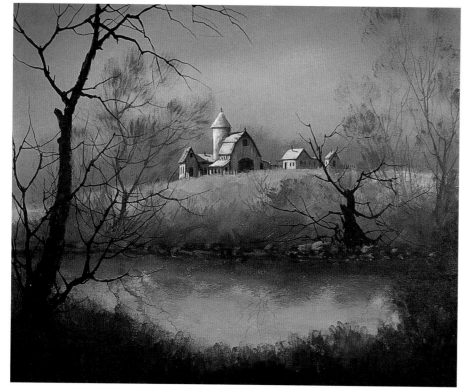

## 15 Paint Tree Trunks

It's rare that Burnt Umber comes in handy, but you'll need it for this step. Use pure Burnt Umber and make it slightly creamy. Block in the main tree trunks with a no. 4 flat sable. Thin the mixture until it becomes inky. Paint in all of the miscellaneous limbs connected to the trunks with a no. 4 script liner brush. Place the limbs at the outer edges of the triangle-shape composition.

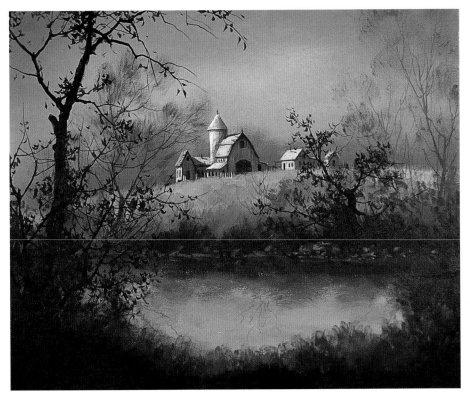

## 16 Add Dark Leaves and Brush

Mix Hooker's Green, Dioxazine Purple and a little Burnt Sienna until the mixture is creamy. Paint in all the leaves at the base of the first tree with a no. 6 flat bristle brush. Switch to a no. 4 round sable and paint in individual leaves. Scatter them on the trees, grouping some for interest. Use interesting negative space and allow plenty of sky to show through.

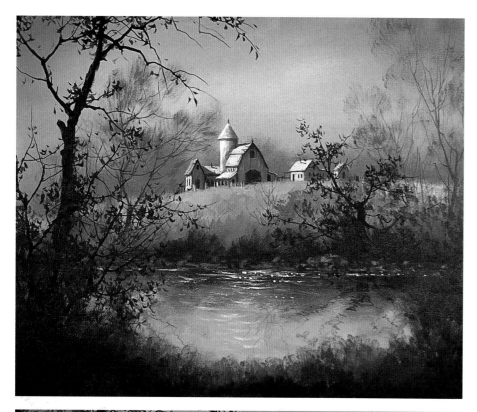

## 17 Highlight Water

Thin a small amount of Titanium White with clean water. Glaze the entire surface of the water area with a no. 10 flat bristle brush. Let the area dry. Highlight the water with pure Titanium White along the edges and in the main body of water with a no. 4 round sable.

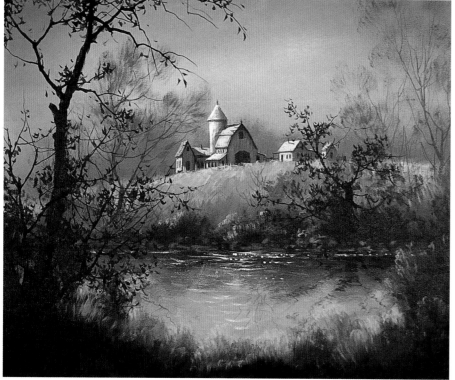

## 18 Highlight Grass and Bushes

There is not much to this step, but it is still important because you add the highlights to give these areas more form. Mix Thalo Yellow Green and Titanium White, or Thalo Yellow Green with a touch of Cadmium Orange. Paint the highlights onto the clumps of grass, bushes and the hillside with a no. 10 or no. 6 flat bristle brush. The highlights add form to these areas.

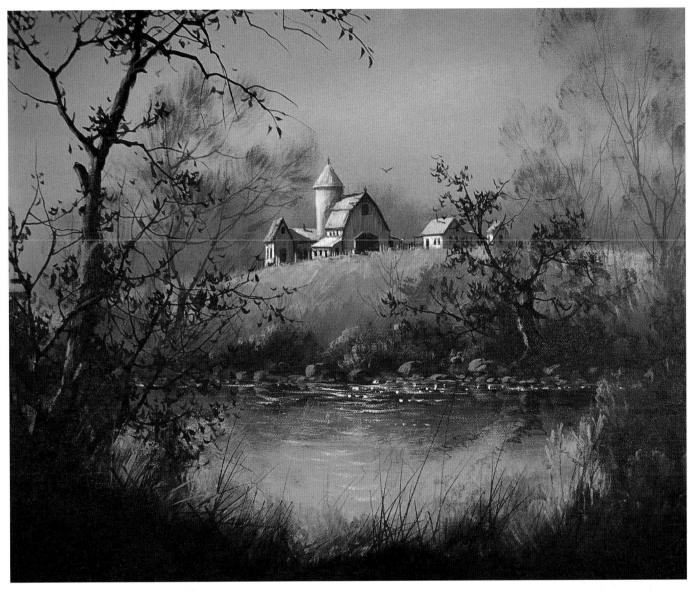

# 19 Final Details and Highlights

As with all other final steps, let your artistic license work for you. Add taller weeds to the foreground and brighten some of the rocks along the shoreline. Add a few brighter highlights to the buildings. Voila! You're finished.

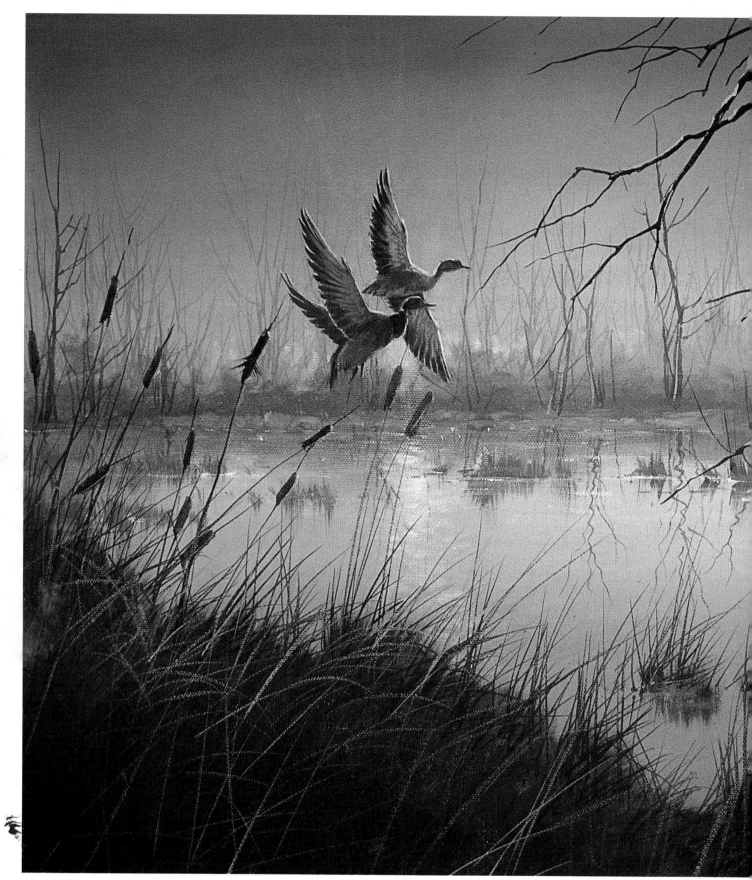

HOMEWARD BOUND
16" x 20" (41cm x 51cm)

# Homeward Bound

*The triangle-shape composition is widely used by wildlife artists, especially those who paint ducks, geese and other water-fowl. What makes this composition so unique is that the main center of interest (the ducks), the main eye stopper (the large dead tree on the right side) and the fillers (the weeds and cattails on the lower left) form a triangle. Use a triangle-shape composition to capture birds in flight.*

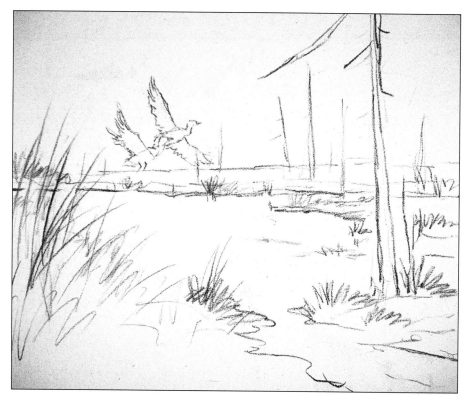

## 1 Basic Sketch

Make a rough sketch of the basic elements of the landscape with a piece of no. 2 soft vine charcoal.

## 2 Underpaint Sky

This is a really unique color scheme. Before you begin, practice this step on a scrap of canvas. Wet the sky area and apply a liberal coat of gesso with a hake brush. Cover the sky well. While the sky is still wet, apply Cadmium Orange, dragging the color across the horizon, and blend it to the top of the canvas. While the sky is still wet, apply Ultramarine Blue across the top of the canvas and blend downward. Blend both areas with a light, feathery brushstroke.

## 3 Underpaint Water

In this step, paint the water with the same technique you used in step 2. The water reflects the sky, so reverse the location of the Cadmium Orange and Ultramarine Blue and feather both colors together. The Cadmium Orange horizon is now at the top of the water and the Ultramarine Blue is at the bottom. To make this step easier, turn the canvas upside down.

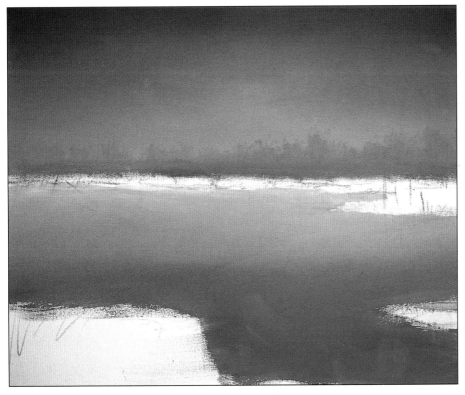

## 4 Underpaint Background Trees

Let the sky area dry before you begin this step. Mix a small amount of Titanium White, Ultramarine Blue and Cadmium Orange in equal parts. Mix these colors until they are creamy. Adjust the value of the mixture until it is slightly darker than the horizon. Paint in the trees, keeping them soft and subtle, with a no. 6 flat bristle brush. Block in the background with the same mixture. Next, darken the same mixture with more Ultramarine Blue. Paint in a second layer of trees. Keep them soft.

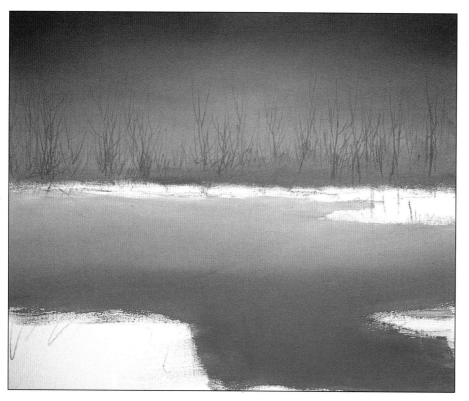

## 5 Paint Distant Tree Limbs

For this step, darken the same color that you used in step 4 with Cadmium Orange and Ultramarine Blue until it is slightly darker than the background trees. Thin it to an inky consistency. Paint in a collection of delicate trees across the horizon with a no. 4 script liner brush. Paint a variety of shapes and sizes for interesting negative space and overlap. Make sure that you don't go too dark.

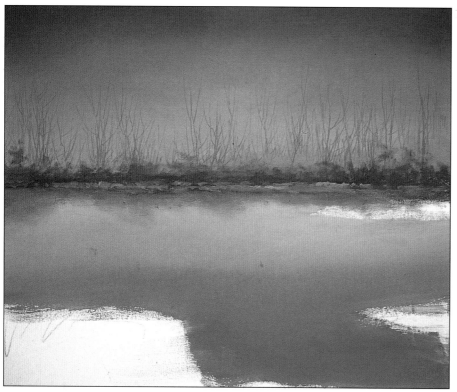

## 6 Block In Shoreline

Mix Ultramarine Blue and Cadmium Orange with a little bit of Titanium White. Make the value three shades darker than the background trees. Block in the irregular shoreline with a no. 6 flat bristle brush. Don't paint the shoreline in a straight line. Instead, overlap some of the shoreline over the background trees. Suggest reflections by dragging a little bit of color through the water.

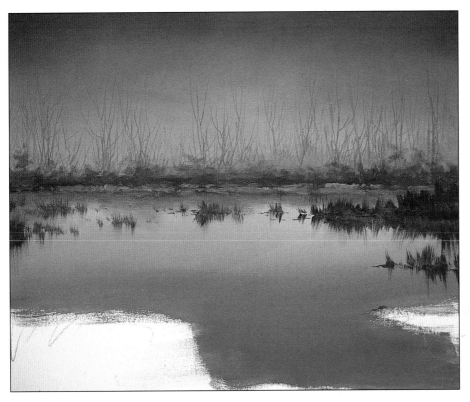

## 7 Add Middle ground Clumps of Grass

For this step, lighten the same mixture of Cadmium Orange and Ultramarine Blue that you used in step 2 with a small amount of Titanium White. Make the middle ground a lighter value than the background. Add small amounts of Titanium White until the value is a middle tone. Paint in clumps of grass, creating a nice variety of sizes and shapes with a no. 6 flat bristle brush. Block in the reflections.

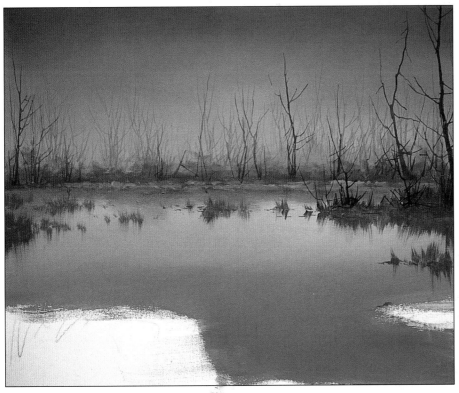

## 8 Add Intermediate Tree Trunks

Mix Cadmium Orange and Ultramarine Blue. Darken the mixture slightly with a small amount of Ultramarine Blue and thin it to an inky consistency. Paint in the intermediate trees and grass along the shoreline with a no. 4 script liner brush. I know you are probably tired of my mentioning this, but use interesting negative space. Overlap the tree limbs in a variety of shapes, sizes and heights.

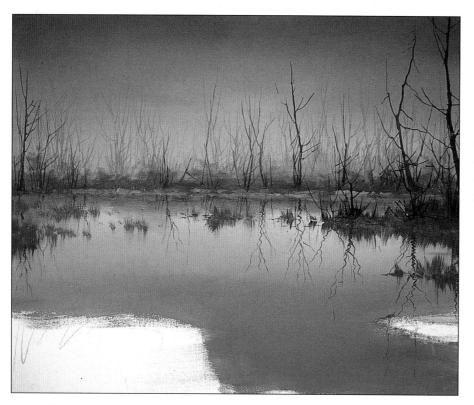

## 9 Reflect Intermediate Tree Trunks

Mix Cadmium Orange and Ultramarine Blue and thin it until the mixture becomes creamy. Paint in the reflections of the trees, beginning where each one is located, with a no. 4 round sable brush. Paint the reflection with a wiggly brushstroke for the trees' reflections.

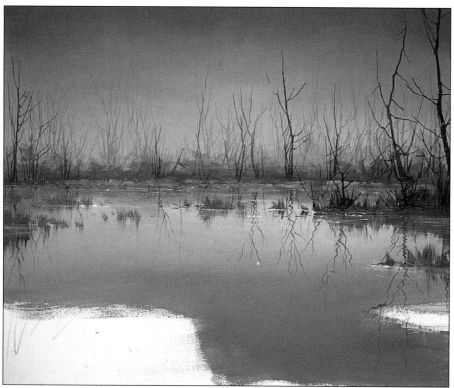

## 10 Highlight Water

Make a milky glaze with a small amount of Titanium White and clean water. Drybrush the mixture carefully across the surface of the water with a no. 10 flat bristle brush. The idea here is to soften the reflections that you have just painted. Paint a few thin highlights along the shoreline for added sparkle with pure Titanium White and a no. 4 round sable brush.

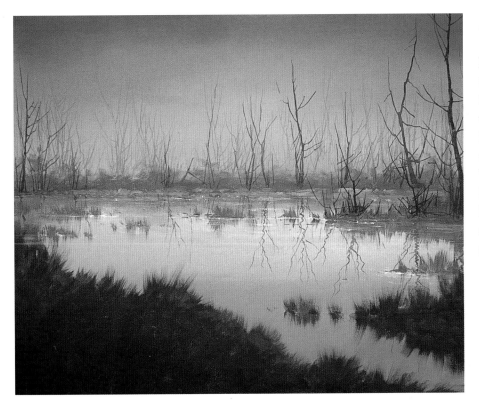

## 11 Underpaint Foreground Grass

Darken the same mixture of Cadmium Orange and Ultramarine Blue that you used in earlier steps with a touch more of Ultramarine Blue. Depending on the overall value of your painting, add Titanium White to lighten the mixture. Paint in the grass with a no. 10 flat bristle brush. Cover the area well with a thick layer of paint. Keep the edges soft and irregular.

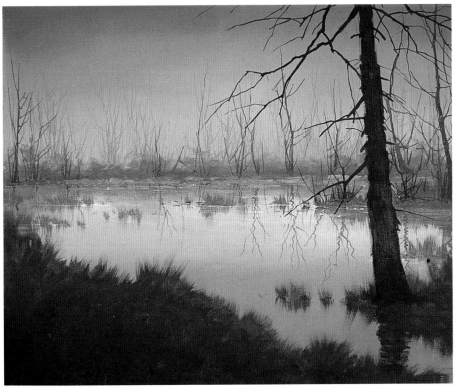

## 12 Underpaint Large Dead Tree

Mix Ultramarine Blue, Cadmium Orange and a little Burnt Sienna until fairly dark. Block in the main tree trunk with a no. 6 flat bristle brush. Cover the area well with a thick layer of paint. Apply the paint in short, choppy vertical strokes. Thin the same mixture until it is an inky consistency. Paint the main tree limbs with a no. 4 round sable brush. Finish the smaller limbs with a no. 4 script liner brush. Once again, make interesting the negative space and overlap a few of the branches.

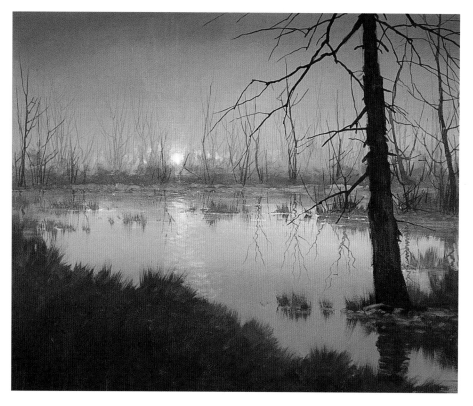

## 13 Add Light Source

To add the light source, mix Titanium White with a touch of Cadmium Orange. Block in the area of sun and then add highlights to the trees with a no. 6 flat bristle brush. Add some of this color to the water directly below the sun. Paint the reflection using short, choppy, horizontal brushstrokes no wider than 1" (2.5cm).

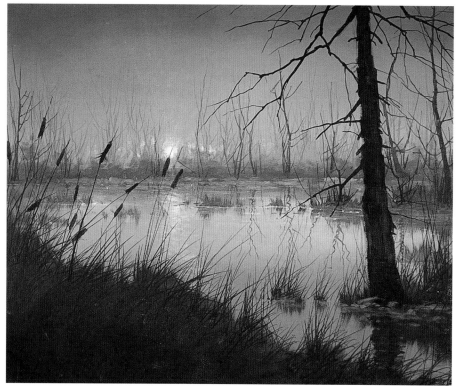

## 14 Paint Tall Weeds in Foreground

Thin a mixture of Cadmium Orange and Ultramarine Blue until it is creamy. At the base of the largest tree, paint in the tall weeds with a no. 4 script liner brush. Add the cattails with a no. 4 round sable brush. Overlap some of the longer stalks for depth. There is no real technique for these cattails.

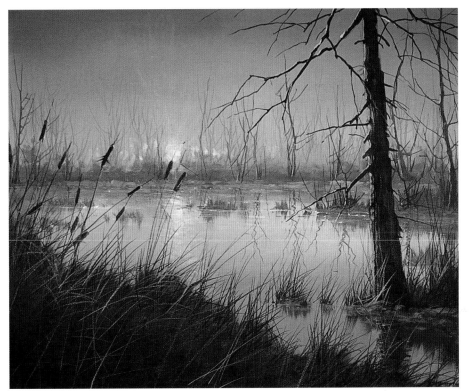

## 15 Highlight Painting

Mix Cadmium Orange and Titanium White until the mixture is very creamy. Accent the left side of each tree with a no. 4 round sable brush. Keep the highlights thin and opaque. Thin the mixture again with water and paint the taller weeds located at the base of the largest tree with a no. 4 script liner brush.

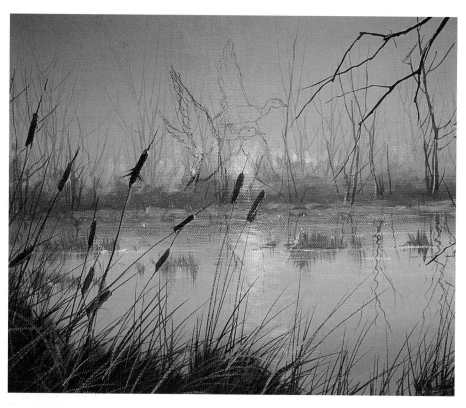

## 16 Sketch In Ducks

Make an accurate outline of the ducks. If a piece of no. 2 soft vine charcoal is too thick for you to make an accurate sketch, use a soft charcoal pencil or a Conté crayon.

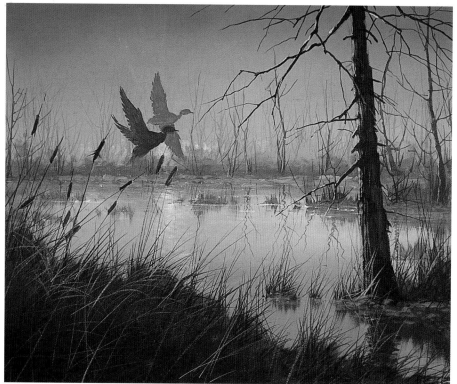

## 17 Underpaint Ducks

Mix Ultramarine Blue, Cadmium Orange and just enough Titanium White to create a middle value. Block in the ducks, covering the canvas well with a no. 4 round or flat sable brush. Avoid adding too many details. The ducks are an important element in the composition, but they should not compete with the other components that you have added.

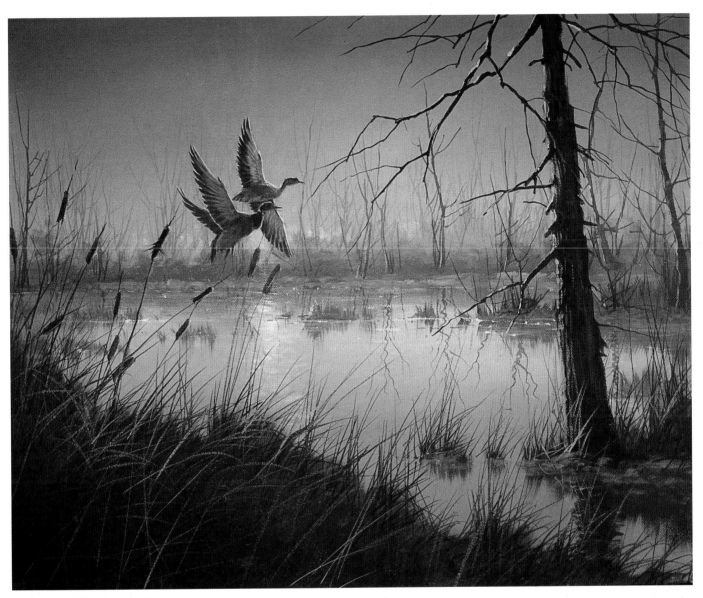

# 18 Highlight Ducks

To highlight the ducks, mix a warm gray using Cadmium Orange, Titanium White and a small amount of Ultramarine Blue. Drybrush the mixture onto the wings and bodies with a no. 4 round sable brush for the feathers. With the same mixture, add even more highlights by painting a thin accent around the outline of the ducks with a no. 4 script liner brush. Paint just enough of an accent to make the ducks stand out.

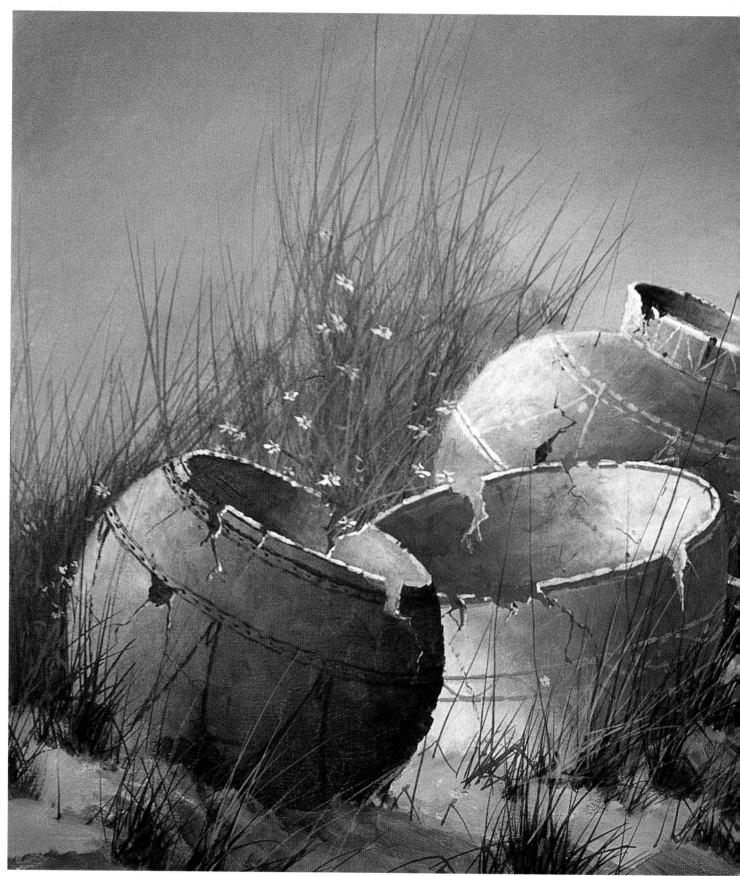

BROKEN POTS
16" x 20" (41cm x 51cm)

# Broken Pots

*This painting is a center-type composition, which is used primarily for close-up paintings like still life and portraits. You guessed it! The pots are the center of interest. Unlike the traditional subjects of triangle and L-shape compositions, center-type paintings use the center of interest to keep the viewer's attention. The pots overlap each other to create interesting pockets of negative space. The eye flows around this composition instead of bouncing from object to object. Fillers like the grass and shadows help tie the composition together. Even with a simple subject, this type of composition can be quite effective and fun.*

### 1 Underpaint Background

This background is mottled, which means that you blend the colors directly on the canvas. After applying a liberal coat of gesso, scatter pure colors all over the surface with a hake brush. Use Dioxazine Purple, Hooker's Green, Ultramarine Blue, Burnt Sienna and Cadmium Yellow. Rinse your brush. Feather the colors together with large, criss-crossing brushstrokes.

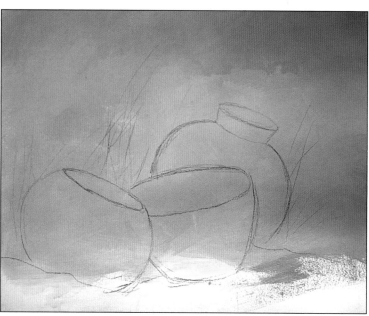

### 2 Basic Sketch

Sketch the shape, location and proportion of the pots with a piece of no. 2 soft vine charcoal. Because there is little room for compositional changes, it is very important that you accurately capture the subject of this painting.

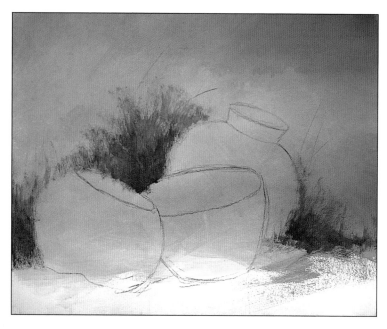

### 3 Underpaint Background Grass

Mix Hooker's green, Burnt Sienna and a small amount of Cadmium Yellow and Titanium White. Mix the value about two or three shades darker than the background. Mix the colors to a creamy consistency. Block in the background grass behind the pots with a no. 10 flat bristle brush. Keep the edges very soft so that you can easily blend in other elements.

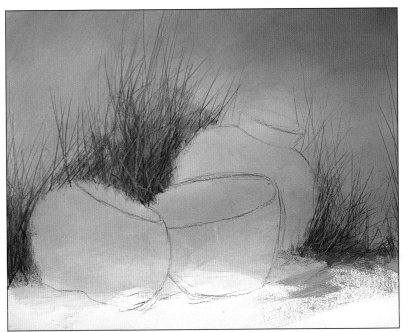

## 4 Add Tall Background Weeds

Darken the color mixture you used in step 3 with a little more Hooker's Green and Burnt Sienna. Thin it to an inky consistency. Paint in a variety of weeds with a no. 4 script liner brush, overlapping some longer weeds for added depth. Lighten the mixture with Cadmium Yellow and a touch of Titanium White. Paint in lighter weeds to break up the darker weeds in the background.

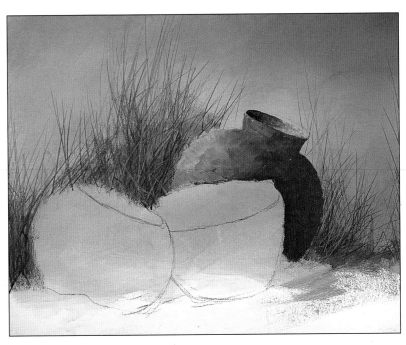

## 5 Underpaint Back Pot

Begin with the shadow side of the pot. Mix Burnt Umber with a small amount of Titanium White. Block in the color at the base with a no. 6 flat bristle brush. Paint along the contour to make the pot round. As you paint across the pot, lighten the value by adding small amounts of Titanium White. Leave the brushstrokes on the pot visible. After you have finished the base of the pot, paint the neck of the pot with the same color mixture and with a no. 4 script liner that you used in the previous section. Paint the inside of the pot, placing the darkest shadow on the left.

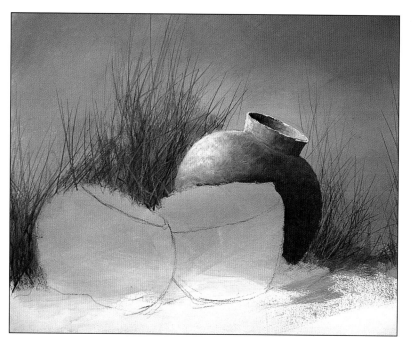

## 6 Highlight Back Pot

Mix Titanium White and a small amount of Cadmium Yellow to the Burnt Umber mixture you used for step 5. Drybrush the mixture onto the left side of the pot with a no. 6 flat bristle brush. Blend the color well. Repeat the step several times to brighten the highlight. After you highlight the main body, paint both the neck and the inside of the pot. Using the same mixture you used to paint the outside of the pot, highlight the rim with a no. 4 round sable brush.

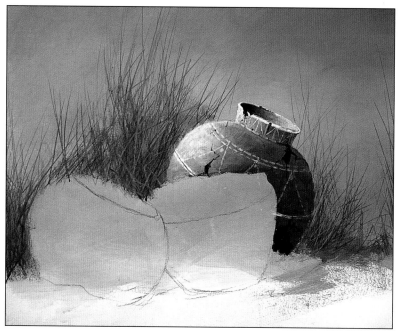

## 7 Detail Back Pot

Use your artistic license for this easy step. Sketch a simple design onto the pots with a piece of no. 2 soft vine charcoal. Thin pure Titanium White until it is creamy. Paint the design, using short, choppy brushstrokes and a no. 4 script liner brush. Remember that these are old pots and the design may be faded out in some areas, especially on the dark side. Paint the cracks with a small amount of Burnt Umber and a no. 4 round sable brush.

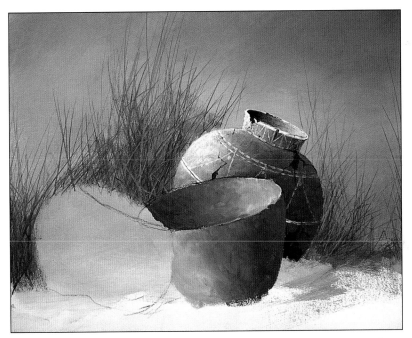

## 8 Underpaint Middle Pot

Paint this pot using the same blending technique you used in step 5. Mix Ultramarine Blue with a touch of Burnt Sienna and a small amount of Titanium White. Paint from the dark side across to the light side, adding Titanium White to create a second and third value.

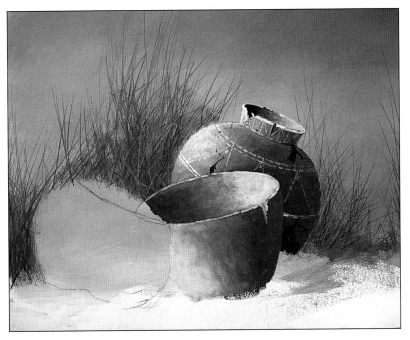

## 9 Highlight Middle Pot

Mix Titanium White with Cadmium Orange. Paint the rim of the pot with this mixture using a no. 4 round sable brush. Keep the highlight soft. Repeat this step several times until the highlight is bright.

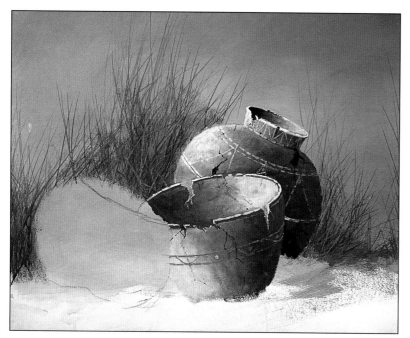

## 10 Detail Middle Pot

Sketch a simple design onto the middle pot. Mix Cadmium Orange and Titanium White. Paint in the design with a no. 4 script liner brush. Add some cracks and broken spots so that the pots appear old. Define the thickness of the walls by adding a final accent to the rim and edges of the cracks.

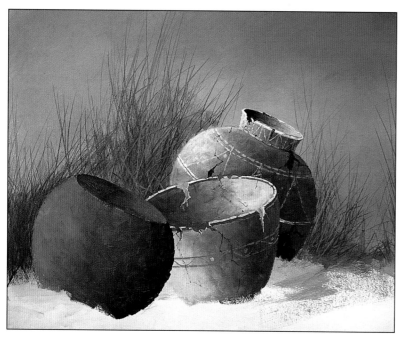

## 11 Underpaint Front Pot

Paint pure Burnt Sienna onto the left side of the pot. Next, mix Titanium White with a small amount of Cadmium Yellow and add this mixture to the side that you painted with Burnt Sienna. Blend the two values across the contour of the pot, using short, choppy brushstrokes to suggest texture. Keep the edges soft. For the inside of the pot, reverse the lights and darks, painting Burnt Sienna on the right side instead of the left. Add Titanium White and Cadmium Yellow to the light area and blend the values together from right to left.

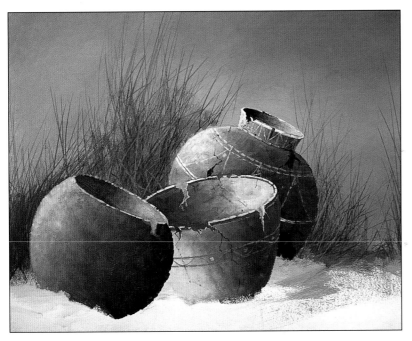

## 12 Highlight Front Pot

Mix Titanium White with a little Cadmium Yellow and a touch of Burnt Sienna. Keep the mixture thick so that the highlight doesn't mix with the underpainting. Paint a broken line on the inside of the pot with no. 4 round sable brush.

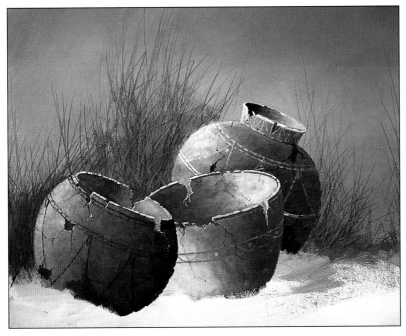

## 13 Detail Front Pot

Mix Burnt Sienna with a little Ultramarine Blue and a very small amount of Titanium White. Paint in any design you want with a no. 4 round sable brush. Keep the design soft and avoid making a solid outline. Highlight the top rim of the pot with pure Titanium White.

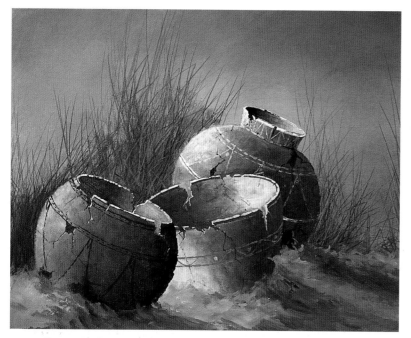

## 14 Add Shadows

For the shadow, mix Burnt Sienna with a little Dioxazine Purple and a touch of Titanium White. Paint the shadows with a no. 6 flat bristle brush. Add the shadow next to the pots and paint it out towards the edges of the composition. Paint the shadow in short, choppy brushstrokes, for movement and texture. Lighten the mixture with Titanium White and a touch of Cadmium Orange. Paint in the lightest part of the shadow.

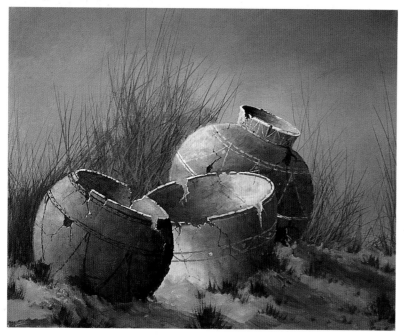

## 15 Add Foreground Grasses

Mix Hooker's Green with a small amount of Burnt Sienna, a touch of Dioxazine Purple and a little Titanium White. Paint in the soft clumps of background grass with a no. 6 flat bristle brush. Scatter the grass throughout the composition. The grass acts as an eye stopper, helping the viewer focus on the pots.

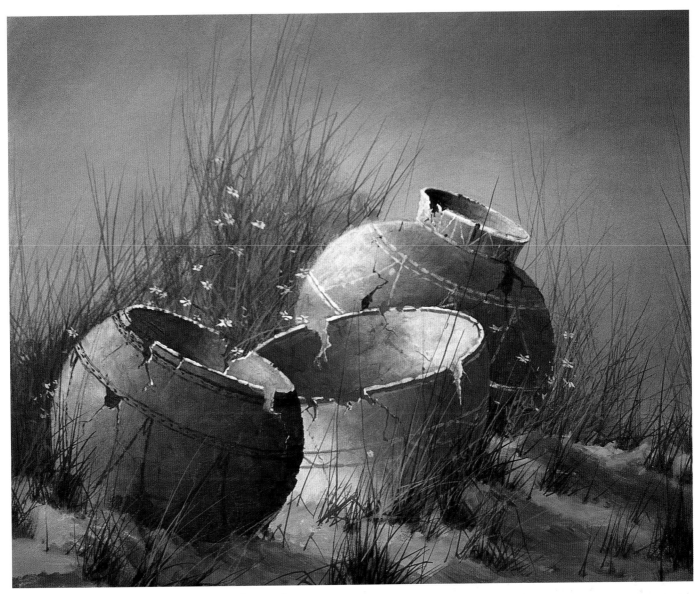

# 16 Miscellaneous Highlights and Details

Thin the mixture used in step 15 until it is an inky consistency. Paint the taller weeds with a no. 4 script liner brush, making sure to overlap some of the weeds for interest and depth. Don't be afraid to make these weeds very tall. Lighten the mixture with Cadmium Yellow and Titanium White. Add some lighter weeds for variety and to add contrast to the darker weeds. Next, add some miscellaneous highlights to the grassy areas. Paint a few small flowers in the foreground in any color you would like. Paint highlights as needed onto the pots, sand and weeds.

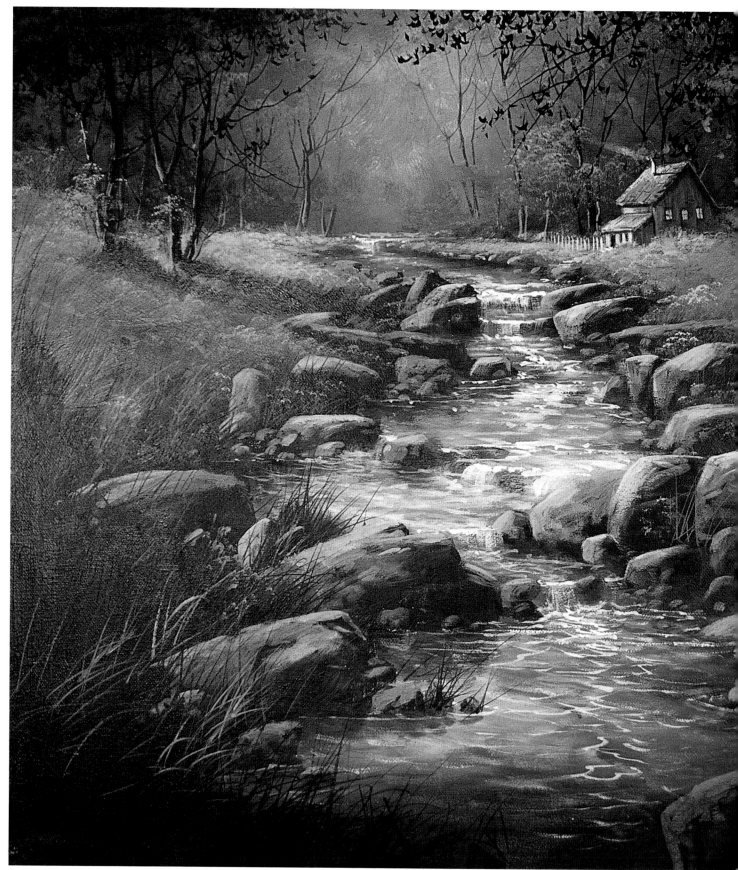

ROCKY WATERS
16" x 20" (41cm x 51cm)

# Rocky Waters

*This is a difficult painting because of the many different elements involved in making it. The painting is designed so that the cabin is the center of interest. The other elements act as fillers and eye stoppers to help complete the painting. It is important that all the elements work together so that the painting can be a success.*

## 1 Basic Sketch

Make a rough sketch of the basic elements in the painting. A simple sketch of the landscape is sufficient to establish the placement of the objects.

## 2 Underpaint Background

For the mottled background, apply touches of pure colors directly onto the canvas. Scatter small amounts of Hooker's Green, Dioxazine Purple, Cadmium Red Light and Thalo Yellow Green across the surface of the canvas. Blend the colors until you have made varied tones in your background. Keep the center of the background lighter than the outer edges.

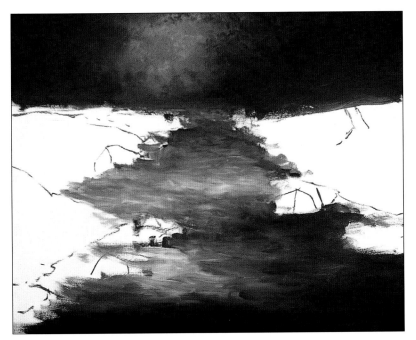

## 3 Underpaint Water

Begin with the the river. Mix Titanium White with touches of Hooker's Green, Ultramarine Blue, Burnt Sienna and a little Dioxazine Purple. Block in the water with a no. 6 flat bristle brush. Paint shorty, choppy brushstrokes for texture. Remember that you will need to make the value slightly lighter in the foreground.

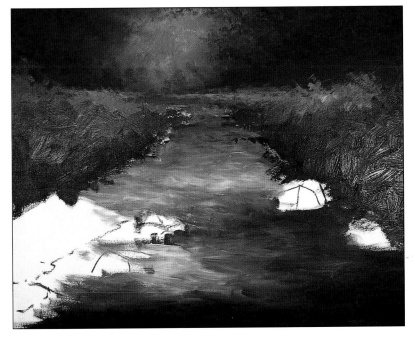

## 4 Underpaint Middle and Background Grass

Mix Thalo Yellow Green with touches of Cadmium Orange, Burnt Sienna and a little Hooker's Green with a no. 10 flat bristle brush directly onto the canvas. Mix the tones until they are on the warm side. Paint the foreground by adding more Hooker's Green and Burnt Sienna to darken the value. Cover the canvas in loose brushstrokes to suggest wild grasses.

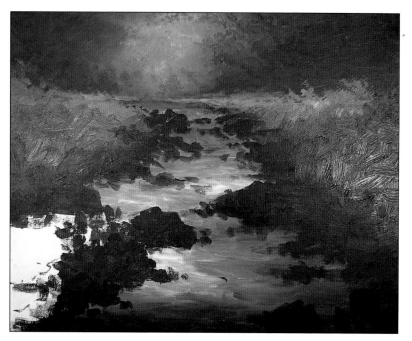

## 5 Underpaint Rocks

This is not a difficult step, but it is a bit intimidating. Mix Ultramarine Blue, Burnt Sienna and a touch of Dioxazine Purple on your palette. Lighten the mixture with a small amount of Titanium White. Block in the rocks with a no. 6 flat bristle brush, covering the canvas well. Darken the value of each rock with a bit more of Ultramarine Blue and Burnt Sienna as you recede into the background. Keep the rocks in the foreground lighter in value.

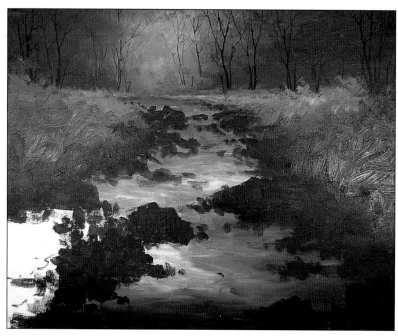

## 6 Underpaint Background Tree Trunks

For this step, add Titanium White to the mixture used in step 5 to block in the rocks. Keep in mind that the value should be slightly darker than the background. Add Ultramarine Blue if it's necessary to darken the value. Thin the mixture to an inky consistency. Paint in the background trunks with a no. 4 script liner brush. Make negative space interesting by keeping the trees outside the center of interest.

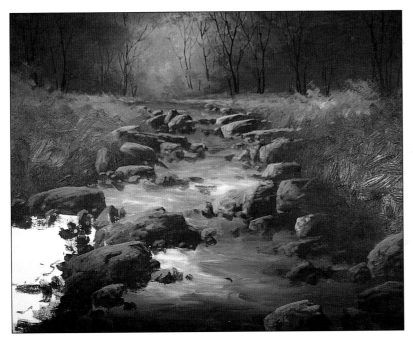

## 7 Highlight Rocks

For this difficult step, mix a highlight by combining Titanium White, a small amount of Cadmium Orange and a little Ultramarine Blue. Thin this mixture until it is creamy. Drybrush this color onto the top left side of each rock with a no. 6 flat bristle brush. Leave visible brushstrokes for texture. Don't make the rocks too bright in this step.

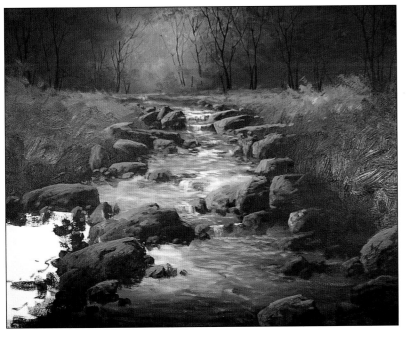

## 8 Highlight Water

Mix Titanium White with small amounts of Ultramarine Blue and Hooker's Green. Mix the colors until they are creamy. Paint short, choppy, horizontal brushstrokes across the water area with a no. 4 flat sable brush. Paint in loose brushstrokes for movement in the water's surface.

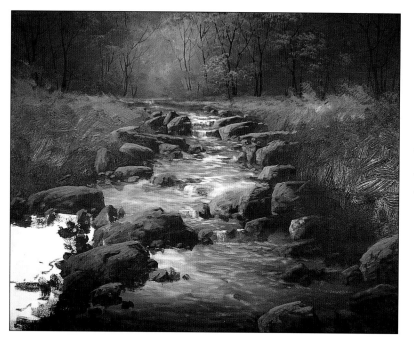

## 9 Add Light Leaves on Background Trees

Use several combinations of colors for this step. Mix Thalo Yellow Green with a touch of Cadmium Orange. Mix Cadmium Yellow with Cadmium Orange or use pure Cadmium Yellow and pure Cadmium Orange. Make the mixtures creamy and paint in the highlights with a no. 10 or no. 6 flat bristle brush. Avoid making the highlight too solid. Paint the leaves letting the underpainting show through.

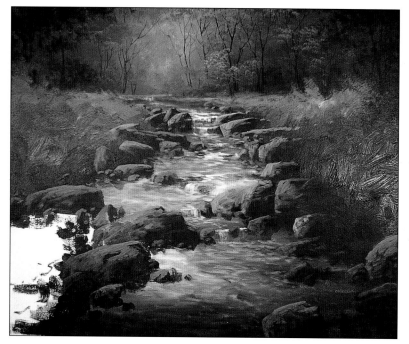

## 10 Add Dark Leaves on Background Trees

This step is identical to the step 9. Mix Hooker's Green, a touch of Burnt Sienna and a little Dioxazine Purple. Make this mixture lighter in value than the background color. Paint in the darker leaves with a no. 10 or no. 6 flat bristle brush. Place these leaves at the outer edges of the canvas so that your eye remains in the center. Keep the leaves light and airy, allowing some of the underpainting to show through.

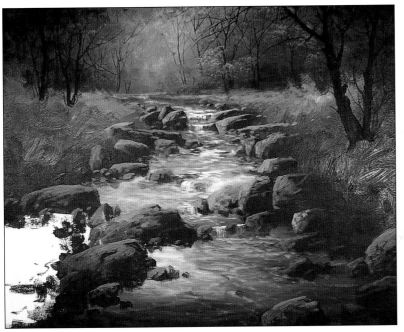

## 11 Add Large Tree Trunks

Plan the placement of the tree before you begin this step. Also, you have a couple of choices of color here. Mix Ultramarine Blue and Burnt Sienna for a rich brown, or use pure Burnt Umber. Make the mixtures creamy and block in the main shape of the larger tree trunks with a no. 4 round sable brush and a no. 4 flat sable brush. Overlap the limbs for depth. Paint the smallest branches with a no. 4 script liner brush.

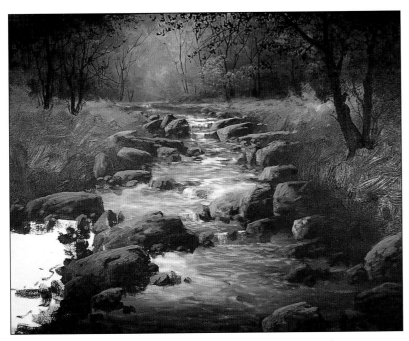

## 12 Paint Large Leaves

Mix Hooker's Green with a little bit of Burnt Sienna and Dioxazine Purple. Mix this color until it is a very dark greenish-brown. Make the mixture creamy and with a no. 4 round sable brush paint the leaves using quick, overlapping brushstrokes. Arrange the leaves so that the tree has an even balance. Leave areas open for interesting negative space.

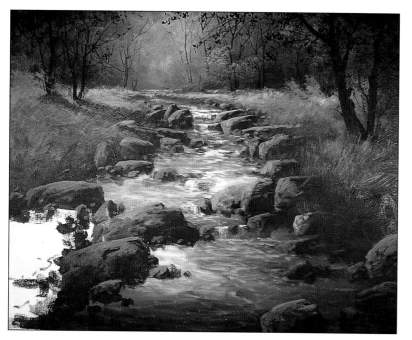

## 13 Highlight Middle and Background Grasses

You can use almost any light color or combination of colors that you want in this step. Some possible color choices are a mixture of Cadmium Yellow and Cadmium Orange, pure Cadmium Yellow or Cadmium Yellow mixed with Titanium White. Don't use bright greens and keep your colors on the warm side. Paint in the highlights throughout the middle ground and background with a no. 6 flat bristle brush. Avoid making the highlights too solid and allow some of the background to show through.

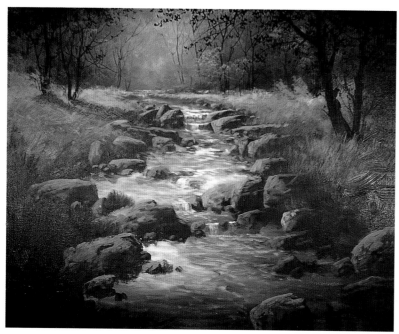

## 14 Underpaint Foreground Grass

This step is quick and easy. Mix Hooker's Green, Burnt Sienna, and Dioxazine Purple. Drybrush the grass by pulling the paint upward to make soft edges with a no. 10 flat bristle brush. Cover the canvas well. You may need to repeat this step a couple of times to get enough of the foreground grass in place.

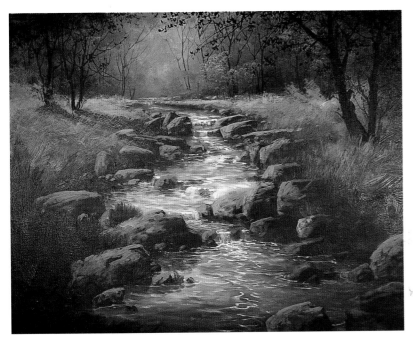

**15 Detail and Highlight Water**
Make a small amount of pure Titanium White creamy and paint highlights around the edges of the rocks and the top of each waterfall with a no. 4 round sable brush. Paint in the highlights heavily so that they are bright and opaque.

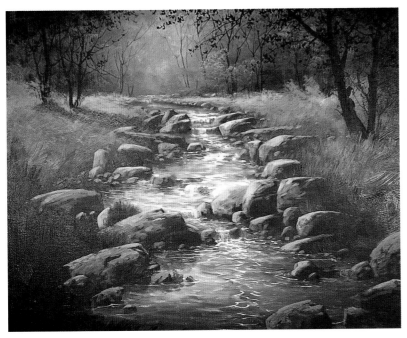

**16 Detail and Highlight Rocks**
Mix Titanium White and Cadmium Orange. If you prefer this mixture to be on the yellow side, add a small amount of Cadmium Yellow. Make this mixture creamy. Highlight the top left side of each rock with a no. 4 flat sable brush. Let some of the underpainting show through. Darken the mixture with a small amount of Burnt Sienna and Ultramarine Blue. Suggest cracks and adjust some of the shapes in the rocks. Keep the rocks in the center brighter in value than those on the edges of the composition.

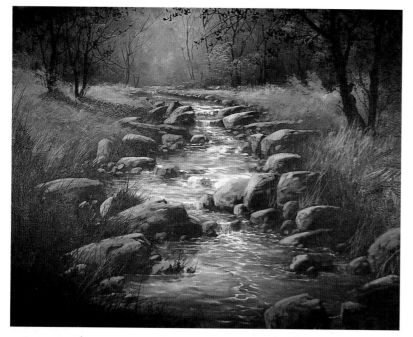

## 17 Add Tall Weeds in Foreground

No surprise here! Mix a dark mixture of Hooker's Green, Dioxazine Purple and Burnt Sienna. Thin this mixture until it's inky. Paint in the dark tall weeds with a no. 4 script liner brush. Lighten the value by adding small amounts of Titanium White. Overlap some of the weeds, painting some at different lengths. Place most of the taller weeds on the left side of the painting and around the rocks.

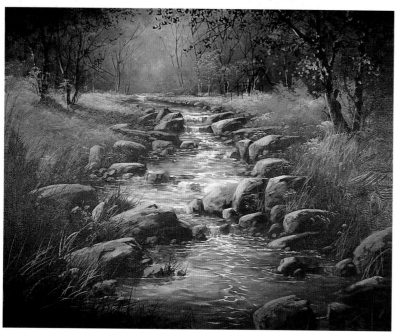

## 18 Sketch the Cabin and Final Highlights

Scatter the wild flowers here and there for a nice touch. Lighten the color of some weeds for contrast. Brighten orange leaves on the large tree to help bring it forward. Brighten the highlights on a few rocks for variety. Brighten the highlights on the water. Again, be careful not to overdo it. Sketch in the cabin with a piece of no. 2 soft vine charcoal.

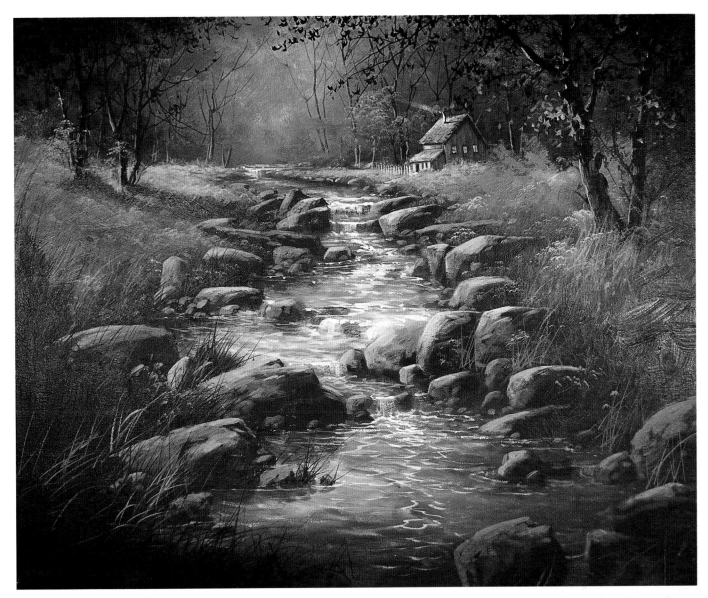

# 19 Add Center of Interest

Although this is the most important part of the painting, it is one of the easiest to paint. Mix Ultramarine Blue, a little Burnt Sienna and Titanium White to make a light gray. Lighten the value by adding more Titanium White. The value should match the surrounding area of interest. Block in the dark side first with a no. 4 flat sable brush. Lighten the mixture with a little more Titanium White and a touch of Cadmium Orange, and block in the light side. Add the doors, windows, overhanging shadows and miscellaneous details. Paint in a few small bushes at the base of the cabin with a mixture of Cadmium Yellow and Cadmium Orange. To finish the cabin, add a white fence and a little smoke from the chimney.

# Index

## A

*A Peaceful Place*, 6-7, 78-9
Accenting, 8-9.
    *See also* Highlighting
Acrylic paint, 11.
    *See also* Colors, mixing
Alcohol, 13.

## B

Background, 110, 118
Birds, 12, 24, 26-27, 95.
    *See also* Ducks, Feathers
Blending, 12
Blocking in.
    *See* Underpainting
Bristle brush, 11-12
*Broken Pots*, 104-5
Brushes, 9-13
Buildings, 26, 28, 79, 86-7.
    *See also* Cabin
Bushes, 41, 43, 52, 76, 83, 87, 125
    dead, 52, 55, 65, 76
    highlighting, 90

## C

Cabin, 30-1, 43, 46, 48-9, 53, 115, 124
Canvas, 11, 16
Cattails, 93, 100
Center of interest, 7, 18, 52, 67, 77, 79, 88, 109, 117, 127
    and eye flow, 19, 43
    sketching, 33, 35
    in triangle-shape composition, 26
Charcoal, soft vine, 11, 17.
    *See also* Sketching
Clouds, 10, 44, 56
    as filler, 22, 28
Color complements, 8, 10
Color wheel, 8, 11
Colors, 10-11
Colors, mixing, 9, 11, 15, 47

grass, 48, 50, 90, 99, 101, 110, 116, 119, 124
gray, 48-9, 62-3, 86
highlights, 51, 53, 58, 60-1, 64-5, 70, 75, 87, 92, 100, 102-3, 105, 112-13, 115, 117, 121, 125
leaves, 89, 91, 122-23
pine trees, 47, 70, 72, 75
rocks, 60, 75, 120, 125
shadows, 52, 76, 87, 116
sky, 9, 44, 68, 82, 96
tree limbs, 51-2, 88, 98
tree trunks, 90, 99, 120, 123
trees, 46-7, 50, 57, 83, 97, 101
water, 83, 85, 97, 119
weeds, 52, 76, 102, 111, 126
Complementary colors.
    *See* Color complements
Composite, 34-5
Composition, 7, 18, 36-41
    Center-type, 25, 41, 109
    L-shape, 28-9, 41, 43, 45, 53, 55, 57, 63-4
    Triangle-shape, 25-7, 35,41, 67, 79, 81, 90, 95
Composition tests, 36-41
*Country Getaway*, 42-3

## D

Dabbing, 8
Details, 12, 85, 87, 125
    final, 52-3, 65, 93, 117, 127
    of pots, 112, 114-15
Double load, 8
Drybrush technique, 8-9, 11, 53. 64, 72, 87, 89, 105, 121
Ducks, 27, 41, 95, 104-5.
    *See also* Birds

## E

Easel, 11, 16
Eye flow, 8, 19, 23, 52, 67, 109.

and center of interest, 18, 43
and sketch design, 30, 32-3
in triangle-shape composition, 26-7
Eye stoppers, 7-8, 18-19, 41, 57, 65, 67, 95, 116-17
    in composite, 35
    in sketches, 32-3
    in triangle-shape composition, 26-7

## F

Feathering, 8, 68, 96, 110
Feathers, 105.
    *See also* Birds
Fence, 29, 63-4
Figure painting, 25
Fillers, 18, 22-3, 27-9, 35, 41, 117
Flowers, 8, 50, 52-3, 76, 117, 126
    as filler, 22, 43
Fluorescent lights, 16
Fog, 9

## G

Gesso, 8-9, 44, 56, 82, 96, 110
Glaze, 8-9, 12, 92
Grass, 10, 12, 21, 41, 55, 64, 71, 83, 119
    background, 110, 119, 124
    as eye stopper, 116
    as filler, 22, 25, 81, 109
    foreground, 48, 90, 101, 116, 124
    highlighting, 50, 65, 92
    middleground, 48, 99, 119, 124
    underpainting, 48, 110, 119, 124
Graying, use of color wheel for, 8

## H

Haze, 9
Highlighting, 8-9, 12, 45, 53, 65, 76, 93, 102-3, 117, 126.
    *See also* colors, mixing, highlights;

*See also* under individual subjects

Hills, 29, 55, 57-9

    underpainting, 57, 84

*Homeward Bound*, 92-3

**L**

Landscape, 43, 118

Leaves, 8, 10, 12, 81, 89, 91, 122-3, 126

Light source, 18, 22-3, 31, 102.

    *See also* Shadows

Lighting, 16

**M**

Materials, 11, 16-17

Mildew, prevention of, 13

Mist, 19

Mistakes, correction of, 49

Mountains, 12, 20, 30, 43, 71-2

    background, 22, 45, 69

    as filler, 22, 28

**N**

Negative space, 7-9, 18, 20-21, 24, 31-3, 49, 89, 109.

    in center-type composition, 25

    in L-shape composition, 29

    and leaves, 91, 123

    and mountains, 45

    and trees, 98-99, 101, 120

**O**

Overlapping, 8, 18, 21, 24-5, 98, 109, 117, 126

**P**

Paint, 11, 13, 15

Palette, 11, 13-15

Palette knife, 11, 17

Pebbles, 22, 25, 55, 59, 73

Photos, 34

Pine trees, 20, 22, 43, 47, 67, 70, 72, 75-6. *See also* Trees

Portraits, 25, 109

Pots, 110, 112-15

*Prairie Relic*, 54-5

Proportion, 31, 48-9

**R**

Reflections, 85, 89, 98, 100

Repetitive objects, 26

River, 34, 119. *See also* Water

Rocks, 12, 21, 32-3, 41, 55, 85, 93, 125

    as filler, 22, 29, 81

    highlighting, 60, 65, 75-6, 121, 125-6

    underpainting, 60, 75, 120

*Rocky Road*, 66-7, 77

*Rocky Waters*, 114-15, 125

**S**

Sable brush, 11-12

Script liner brush, 11-12

Scrubbing, 9, 12

Scumbling, 9-10, 12

Shadows, 18, 22-3, 28, 41, 52, 72, 76, 116, 127.

    *See also* Light source

    color of, 52, 76, 85, 116

    as filler, 25, 109

Sketching, 30-4, 46, 61, 104.

    *See also* under individual subjects

    basic, 34, 44, 56, 68, 82, 96, 110, 118

    thumbnail, 7, 30-34

    watercolor, 31, 33

Sky, 9-10, 82

    underpainting, 44, 54, 68, 96

Spray bottle, 11, 13, 15, 17

Sta-Wet Palette, 11, 13-14

Still life painting, 25, 109

Sunlight, 9, 45, 70

Supplies, 11, 16-17

**T**

Texture, 48, 51, 58

Thumbnail sketch.

    *See* Sketches, thumbnail

Toothbrush, painting with, 59, 73

Tree limbs, 12, 21, 24, 50-52, 72, 88, 90, 98, 123

Tree stump, 27, 41

Tree trunks, 24, 49, 88, 90, 99-100, 120, 123

Trees, 26, 41, 57, 75, 81.

    *See also* Pine trees; Tree limbs; Tree stump; Tree trunks

    background, 46, 57, 83, 97, 122

    as center of interest, 28, 43

    dead, 21, 41, 52, 95, 101

    as filler, 29, 55

    highlighting, 46, 51, 58

    sketching, 30-31, 34, 49

    underpainting, 46, 50, 57, 83, 97

Triple load, 8

**U**

Underpainting, 9-10, 12, 44, 86.

    *See also* under specific subjects

    background, 110, 118

**V**

Value, 10, 47, 76

Varnish, 11

**W**

Wash. *See* Glaze

Water, 81, 125.

    *See also* River highlighting, 92, 100, 121, 125-6

    underpainting, 83, 97, 119

Water tank, 29, 55, 62-3, 65

Waves, 32-3

Weeds, 12, 19, 52, 55, 76, 93, 95, 102-3, 111, 117.

    as fillers, 41, 43, 81

    foreground, 102, 126

Wet-on-dry, 10

Wet-on-wet, 8-10, 12

Wet palette system, 11

White pigment.

    *See* Gesso

Wildlife painting, 25, 95

Windmill, 29, 55, 59, 61, 65

Window, in composition, 27, 81

Wire, 12, 67

Wood, weathered, 87

# Discover just how much *fun* painting can be!

Learn how to properly execute basic acrylic painting techniques—stippling, blending, glazing, masking or wet-in-wet—and get great results every time. Jacqueline Penney provides five complete, step-by-step demonstrations that show you how, including a flower-covered mountainside, sand dunes and sailboats, a forest of spruce trees and ferns, a tranquil island hideaway and a mist-shrouded ocean.

ISBN 1-58180-042-8, hardcover, 128 pages, #31896-K

Render the smallest of animals into living works of art! Step-by-step mini-demos show you how to replicate the most intimate animal features. Stephen Koury provides background information and detailed descriptions for a variety of creatures, including butterflies, bees, spiders, dragonflies, beetles, amphibians, hummingbirds and small mammals.

ISBN 1-58180-162-9, hardcover, 144 pages, #31911-K

Here's the reference you've been waiting for! Inside you'll find 28 step-by-step demonstrations that showcase the methods that can help you master the many faces of acrylic painting-from the look of highly controlled transparent watercolor to abstract expressionism, and everything in between. Seven respected painters make each new technique easy to learn, illustrating just how versatile acrylics can be.

ISBN 1-58180-175-0, paperback, 128 pages, #31935-K

Claudia Nice introduces you to the joys of keeping a sketchbook journal, along with advice and encouragement for keeping your own. Exactly what goes in your journal is up to you. Sketch quickly or paint with care. Write about what you see. The choice is yours-and the memories you'll preserve will last a lifetime.

ISBN 1-58180-044-4, hardcover, 128 pages, #31912-K